EAST TENNESSEE BEER

EAST TENNESSEE BEER

A Fermented History

AARON CARSON & TONY CASEY

AMERICAN PALATE

Published by American Palate
A Division of The History Press
Charleston, SC
www.historypress.net

Copyright © 2016 by Aaron Carson and Tony Casey
All rights reserved

Cover image of skyline courtesy of Alan Dockery.

First published 2016

Manufactured in the United States

ISBN 978.1.46711.869.9

Library of Congress Control Number: 2016930880

Notice: The information in this book is true and complete to the best of our knowledge. It is offered without guarantee on the part of the authors or The History Press. The authors and The History Press disclaim all liability in connection with the use of this book.

All rights reserved. No part of this book may be reproduced or transmitted in any form whatsoever without prior written permission from the publisher except in the case of brief quotations embodied in critical articles and reviews.

CONTENTS

Acknowledgements	7
Introduction	9
1. Leading the Nation: The Temperance Movement	11
2. Pre and Post Prohibition: Let the Good Times Roll	13
3. White Lightning Strikes	17
4. Distributors and the Distributed	22
5. Regulators and the Regulated	27
6. Gone but Not Forgotten	31
7. Beer Trailblazers	35
8. Craft Beer Adjuncts	44
9. The Tri-Cities Craft Beer and Cider Renaissance	69
10. The Knoxville Craft Beer Renaissance	94
11. Coming Soon to a Tap Near You	126
12. Now It's a Party	132
13. Leading Tennessee	137
Bibliography	149
Index	151
About the Authors	155

ACKNOWLEDGEMENTS

It's a truism in this section of every book, but this wouldn't have come together without the help of the following people. Thanks for your time, support and, most importantly, the beer you're willing to share with us.

State Representative Jon Lunberg
Miles Burdine
Robert Brents
Anthony Aceves
Ashley Casey, loving and supporting wife of the author
Diane and Willie Thompson
Jason "Ratchet" Carpenter
Stephanie Carson, Gypsy Circus and the author's inspiration
Jimie Barnett and Myron Woods, Triple B Brewery
Brian Connaster, Sleepy Owl Brewery
Ken Monyak, Bristol Brewery
Erich and Pam Allen, Studio Brew
Jimmie Daughtery and Christopher Coada, Holston River Brewing Company
Michael Foster and Devin Rutlege, Depot Street Brewing
Matt Raby, Tennessee Championship of Beers
Andrew Fisher, Tri-Cities Craft Beer Week
Andrew Felty, Brewly Noted Beer Trail
Michael Landis, cheese and libation expert
Eric and Kat Latham, Sam Pettyjohn, Johnson City Brewing Company
Margaret Stolfi, Joe Baker and Jeremy Walker, Yee-Haw Brewing Company
John and Jill Henritze, JRH Brewing

Acknowledgements

Joey Nichols, Libation Station
David and Jenny Lockmiller, Jacob and Kelly Grieb, Atlantic Ale House
Frank Wood and Mike Hubbard, Holston Distributing
Rob Sampson, Cherokee Distributing
Brant Bullock, King Family Farm
Alan Bridwell, local historian
Adam Palmer, Saw Works Brewing Company
Marty Velas, Fanatic Brewing Company
Stephen Apking and Matt McMillan, Hexagon Brewing Company
Shawn Kerr, Brew Mob
Craft Beer Radio
Steven and Jen Dedman
Knoxville News Sentinel
Knoxville Mercury
Nathan Baker, Sam Watson and John Molley, *Johnson City Press*
Calvin M. McClung Historical Collection
Knoxville Lost and Found
Dr. Todd White, South College Professional Brewing Science program
Isaac Privett, Cold Fusion
Paige Travis, Brewers' Jam
Roy Milner and Daniel Heisler, Blackberry Farm
Aaron McClain, Crafty Bastard Brewery
Mike and Tracy Frede, Last Days of Autumn Brewing Company
Adam Ingle, Alliance Brewing
Ramzi Murat, high school English teacher
Logan Wentworth, Scruffy City Brewery
Matthew Cummings, Pretentious Beer Glass Company
Zack Roskop, Knox Brew Tours
Don Kline Jr. and Rob Shoemaker, Knox Beer Snobs
Bob Winkel and Steve Merrill, Eagle Distributing
Ron Downer, famed Knoxville brewer
Al Krusen, Woodruff's Brewing Company
Jeff Robinson and Donald Craig-Grubbs, Blackhorse Pub & Brewery
Christopher Snyder, Bluetick Brewery
Roger Flynn and Nathan Robinette, The Casual Pint
Chris Morton, Bearden Beer Market
Carl Clements, Bubba's Barrels
Steve and Jennifer Dedman, Chisholm Tavern Brewing
Cold Fusion Brewing

INTRODUCTION

In the opinion of the authors of this book, the East Tennessee region—from Knoxville through the Tri-Cities—wasn't ready for a book like this. That's not meant in a conceited way, but more so to be a compliment to the people you'll find in the pages of this book. Without their hard work, drive, dreams and effort, there would be little to write about in regard to the ever-expanding craft beer market in this region.

Just a few years ago, while there were a few brewers scattered about, it wouldn't be fair to say that a collective momentum was building up.

A lot of credit needs to be given to those early pioneers in this area who made it through those dark times to join the new batch and new breed of brewers in a march to significance.

That significance is here, and we wanted to share with you a guide for how you can be a part of the fun. With this book, we set out on a mission to specifically share with you the stories of these brewers and small business owners and how they want to serve their customers, the region and the country.

We hope you enjoy what you read and decide to make trips to each of these fine establishments.

1
LEADING THE NATION

The Temperance Movement

By 1922, the temperance and anti-saloon movements were at the peak of their popularity. In 1879, Knoxville had an estimated twenty-five saloons, where, some records show, 5,000 drinks a day were served. One estimate during that era noted that each of the city's males would be served 12.3 drinks per day, and the daily expenditure for alcohol in those twenty-five saloons hit $500 a day.

The temperance meeting around Market Hall in 1907 brought together forces of influence that had never before been aligned in their common

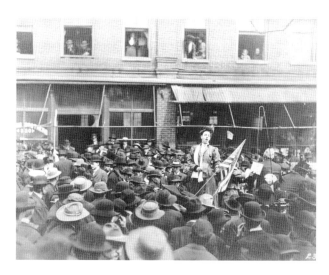

Vera Smith singing to voters in the South Seventh precinct, where three-quarters of the voters were for the wet ticket in 1907. *Courtesy of Abby Crawford Milton Collection and McClung Historical Collection.*

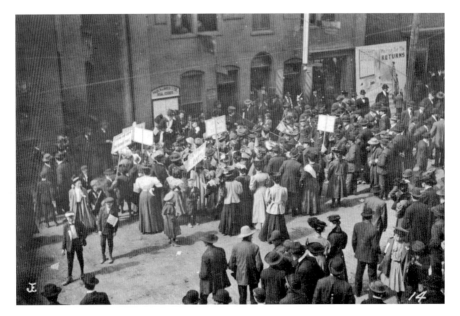

The temperance movement. It's the drys versus the wets in 1907. *Courtesy of the Thompson Photograph Collection and Calvin McClung Historical Collection.*

desire to facilitate the prohibition agenda. Senator Cormack was one of the primary participants in the meeting. Prior to the Market Hall meeting, there was a pre-meeting at Church Street Church to unite the proponents of the temperance movement, including Captain William Rule and Professor Claxton.

The followers of temperance swept the city of Knoxville; the dry majority beat the wet majority by nine-tenths in the 1839 vote. Reverend Robert B. Billue helped form the Union Temperance Society with thirty-seven members after the vote. The vote helped usher in prohibition to the region.

The legions of temperance rallied around Market Hall on February 11, 1907, and, without a dissenting vote, went on record for the application of the Adams Law to Knoxville, which wiped out any business in the city where whiskey was bartered or sold.

2
PRE AND POST PROHIBITION

Let the Good Times Roll

The Knoxville Brewers Association (KBA) was established in 1886, with supply routes via railroad tracks built along the building's perimeter. The Knoxville Brewers Association built a rather large beer brewing campus, complete with a brewhouse, a stock house, a bottling house, cold storage and stables. In 1890, the Knoxville Brewers Association reported a capacity of fifty thousand barrels per year. The KBA was proud of its "Pure Lager Beer."

The KBA became the Knoxville Brewing Company during the late 1880s. It reported using "fine malt and hops from the U.S. and Germany." The company had thirty employees, including a night watchman "around the clock," according to the Sanborn maps. The KBC had a catchy slogan: "Brewers, Bottlers, and Shippers of the Celebrated Export Lager Beer."

Believe it or not, that phrase failed to catch on, and the company was sold by order of the court for $37,000. Prior to that, the company had reported assets of $225,000 and liabilities of $135,000, so the purchaser got an exceptional deal. The brewery was reorganized under the moniker New Knoxville Brewing Company (NKBC) in July 1895.

The NKBC failed to make it more than a year before it was sold. Edward S. Raynor and company opened the East TN Brewing and Malting Company (ETBMC) in 1896 at the NKBC brewery. The ETBMC dropped the malting portion of its moniker and became the East Tennessee Brewing Company (ETBC) under the direction of Matthew Senn, F&H Wisegarber, W.H. Lane and, back from the KBA, brewmaster William Meyer. The ETBC offered

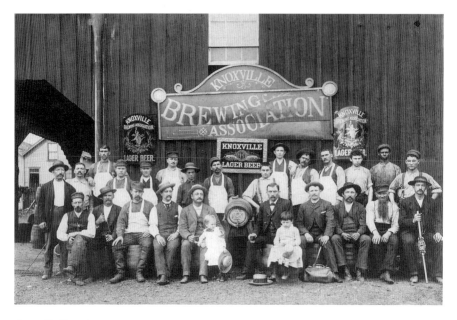

Knoxville Brewing Association's brewing team. *Courtesy of the* Knoxville News-Sentinel.

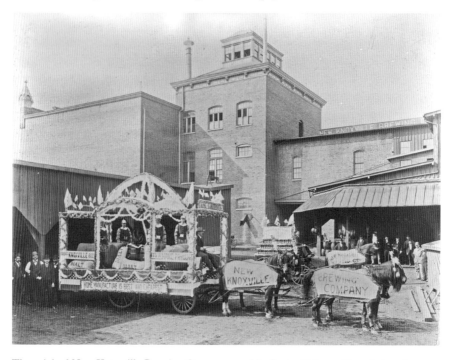

The original New Knoxville Brewing Company and its float—"Home Manufacture Is Best and Cheapest"—in the 1920s. *Courtesy of the Thompson Photograph Collection and McClung Historical Collection.*

A Fermented History

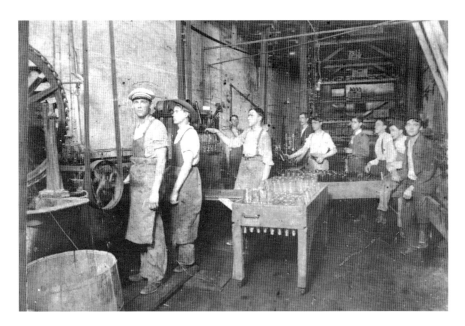

Working the shift at East Tennessee Brewing Company in 1905. *Courtesy of the Thompson Photograph Collection and Calvin McClung Historical Collection.*

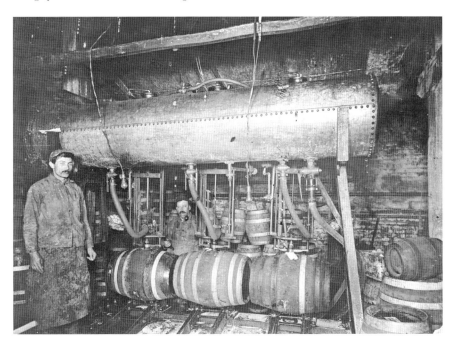

Workers at East Tennessee Brewing Company filling up kegs in 1937. *Courtesy of the Thompson Photograph Collection and McClung Historical Collection.*

two beers, Shamrock and Palmetto. The company claimed that its beers were "commended by the medical profession." Guinness does not uniquely hold that claim to fame.

The ETBC had the longest tenure on the site, lasting until 1915. In 1915, the city passed the Four Mile Prohibition Law. That law effectively ended alcohol production at the plant, officially anyway. The brewery transformed into an ice-making plant, though clandestine brewing still went on. The Union Beverage Company bought the brewery in 1916 to manufacture syrup for Jitney Cola. The brewery was subsequently closed later that year.

3
WHITE LIGHTNING STRIKES

"Saloons, Get Away from Knoxville"
The men down South have taken a notion
To drive the rum shops into the ocean,
Get away, get away, get away from Knoxville!
Chorus.
Get away, get away!
With the temperance band
We'll take our stand
To drive saloons from our Southern land,
Get away, get away, get away from Knoxville!
Away down South in the land of cotton
Where old King Rum is dead and rotten,
Get away, get away, get away from Knoxville!
We'll drive saloons from Knoxville's border
And have a town of law and order,
Get away, get away, get away from Knoxville!
We'll free the children from temptation
And make them strong for home and nation,
Get away, get away, get away from Knoxville!
Now the friends of the right are in the saddle
And we'll make the liquor gang skeedaddle,
Get away, get away, get away from Knoxville!
—Mrs. Nannie Curtis, to the tune of "Dixie"

Riddled in fact and perhaps some fiction, there's no doubt that illegal moonshine—or 'shine, as it's so often called—played a big role in East Tennessee alcohol culture. Because of the illegal activity surrounding its distribution through different time periods, it caught the attention of drinkers and pious Christian women. It both set the region behind in alcohol development and possibly made it more marketable.

Brewers in this book have said several times that Tennessee is well behind the rest of the United States. The West Coast and other regions have already experienced for several years the craft beer boom East Tennessee is currently going through. The brewers aren't wrong that Knoxville and the Tri-Cities are a few years delayed.

If blame can be placed, it might go in the direction of the trouble that came out of prohibition and the illegal making and selling of moonshine. Had people not literally gone blind drinking errantly produced hard mountain water, the craft beer industry's current set of hurdles in the Appalachian Mountains might not be as difficult. It is hard to come back from such a damning history.

Let's share with you, the reader and presumed lover of beer, some of the local history. Tennessee, of course, was the state in which the infamous moonshiner Marvin "Popcorn" Sutton committed suicide rather than face federal prison time due to his mountainous lab experiments. His wife, Pam, has since gotten on the right side of the law and continued her husband's tradition by putting out Popcorn Sutton's Tennessee White Whiskey. When Pam Sutton made a stop at a Johnson City liquor store in late 2013, she spoke about the relationship she shared with her husband and his sense of tradition. She said her husband treated her like a queen and that she loved him to death and was elated to be carrying on his liquor legacy.

Though the Suttons had been 'shining for a long time, the same tradition has been carried out in the Tennessee and Appalachian Mountains for decades. In fact, for many communities during the prohibition era, the precursor to Sutton's now legal moonshine was the best way to get a buzz.

To get it from one point to another during prohibition, booze runners had to make their cars faster than those of Johnny Law. From these souped-up vehicles sprouted the sport of NASCAR, which, perhaps coincidentally, has one of its most famed tracks—Bristol Motor Speedway—in the same area.

It was reported in the *Knoxville News-Sentinel* that 1970 was a big year for agents from the Treasury Department's Alcohol, Tax and Firearms branch in terms of a crackdown on illegal moonshine operations. That year alone, 426 illegal stills were brought down in the Volunteer State. According to

A Fermented History

Getting moonshine the old-fashioned way: just raid it. Sheriff Walter Anderson and his deputies in 1925. *Courtesy of the Thompson Photograph Collection and McClung Historical Collection.*

the agents, 90 percent showed signs of lead salts, which can cause blindness or paralyze or break down the central nervous system. They were taking enforcement seriously but felt they had the right to because of the possible consequences of tangling with a bad batch of moonshine.

Mike Maurer, one of the agents, gave credit to the region in which much of this illegal booze was being made. "Most of the liquor, proportionately, is still found in the Southeastern states," he said.

The tradition of cracking down continued about three decades later, according to the *Knoxville News-Sentinel*'s Morgan Simmons in the 2010 article. A raid of statewide stills turned out much of the same results of 1970. What the state agents learned with this raid was that people in Appalachia were still making moonshine. Inside a single barn in Cocke County, they found eight stills that yielded three hundred gallons of white lightning. Nine years after that, in 2008, enforcement officers took one hundred gallons in Jefferson County. One year later, in Hawkins County, a Nashville moonshining operation was shut down.

As much as it seems that the tradition is living on, with big busts around Tennessee and conversions to less harsh, legal varieties, Tom Des Jean, a cultural resource specialist with the Big South Fork National Recreation Area—very near to where the largest moonshine bust on record was found—said a lot of moonshine recipes are dying off with the liquid's makers.

"We got tons of oral history on this," he said to the Knoxville newspaper. "All these old moonshiners are dying off, and their recipes are going with them."

He said a lot of moonshine was mixed with salts over the years to help with chaffed cow udders, as well as using their components for medical and herbal remedies.

Per state law, retail locations must also be more than five hundred feet from a mortuary, church, hospital, park, residence or school. Further, *Metro Pulse* shares some other rather comical beer-related laws from the city of Knoxville: "No beer shall be sold on premises upon any part of which dancing is allowed, unless the cleared area provided for dancing shall contain at least one hundred forty-four square feet of floor space." Apparently, an eleven- by eleven-foot dance floor just won't do if beer is served, as a twelve- by twelve-foot area on which drinkers can make fools of themselves is just the right amount for a righteous time.

Another doozie is the city's policy on alcohol and strip clubs. Between 6:00 p.m. and 1:00 a.m., no alcohol can be served, but there is a "bring your own booze" option. City and county regulators issue four different kinds of beer permits and have the right to strip them away just as quickly as they've granted them. These include on-premises, for restaurants and bars, and off-premises, for grocery stores, gas stations, wholesalers and manufacturers.

In 2009, $320 was the cost of a beer permit, which is broken down into $250 for the permit, $20 for the city or county license, $25 for a newspaper publication notice and then a $25 criminal record check fee. On top of that figure sits a yearly $100 privilege tax fee. At the time of the *Metro Pulse* article, there were 579 permits issued in Knoxville, which accounted for 1 per 300 people, or 6 per square mile. Out into the county, the numbers were fewer, 156 total, or 1 for every 1,334 people and less than half a permit per square mile, showing us what we already knew: people like to travel into Knoxville to do their drinking rather than throw them back out in the weeds.

Around the Tri-Cities, when harkening back to the older days, à la European style, brewers with the bright idea of introducing the idea of a brewery as a meeting place for small cities and towns often have to petition their respective municipalities to allow their line of work. This was exactly

what Michael Foster had to do in Jonesborough when he opened Depot Street Brewing in the mid-2000s, having to basically hold the hand of the town to get laws written that would allow his business.

This is what the corporate folks at the Casual Pint have had to do in several of the cities in which they've moved their respective franchises, mostly around Tennessee and its neighboring states. Because there's a hangover of anti-alcohol laws on the books, there often have to be rewrites and edits to allow for this kind of blossoming small business. And, luckily, we're finding that small governments often want to make it easier for businesses like Foster's to come into their towns because of the tax revenue, excitement and growth that comes with it. Whereas they say, "you can't fight city hall," you also can't fight the momentum of this healthy and flourishing industry.

4
DISTRIBUTORS AND THE DISTRIBUTED

From Knoxville to the most northeastern point of Tennessee, three beer distributors share the burden and privilege of making sure commercial accounts—grocery and convenience stores or bars and restaurants—have beer to sell.

This short list of local distributors includes Knoxville's (and Kingsport's) Cherokee Distributing Company, Eagle Distributing Company out of Knoxville and Holston Distributing Company in Johnson City.

When deciding whether to self-distribute or go through one of these companies, a craft brewery will weigh its options. While signing on with one of these distributors comes at a cost, and often an exclusive lifetime contract, it can't be denied that the history and reputation of East Tennessee's three distributors comes into play. These reputations can just about guarantee a certain amount of sales, which is very tempting for brewers opening up for the first time.

Some have even done a bit of a hybrid distribution model. Fanatic Brewing Company self-distributes around Knoxville but uses Cherokee Distributing in the outside counties. George Sampson, president of Cherokee, talked about this new business model. He said it's too early to see the results, but he's certainly willing to try the partnership. Sampson said:

> [Fanatic Brewing is] *actually self-distributing in Knox County, when we're handling the surrounding counties. That's the first time we've ever done that, and we'll see how that works out for both of us. It's too early to*

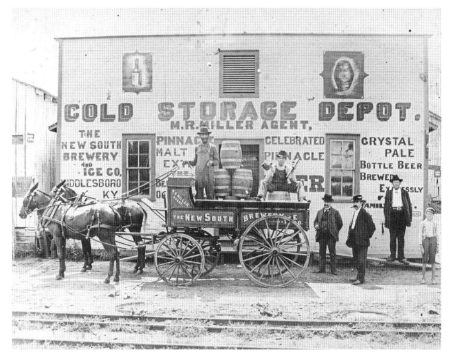

New South Brewery transporting its finest to East Tennessee. *Courtesy of the Burr Harrison Collection of the ETSU Archives of Appalachia.*

tell whether that will work, but they wanted to try it and we want to try it with them.

While this obviously isn't the typical agreement come to by his father, who started the business in 1958, it might become a reality of beer distribution for the future. When the business started, it wasn't craft beer Cherokee was selling as much as whatever the brewhouses were giving them. As the years passed, the junior Sampson took ownership of the company. His cousin Rob Sampson, who had a different distributing company, eventually decided that it was time to merge the two entities after ten years of separate business to form Cherokee Distributing, with central operations in Knoxville.

"It basically enabled us to grow our inventory levels and get fresher beers in the market and simplified a complicated process," George Sampson said. And by that, he's talking about locally produced craft beers, which have been as much a shot in the arm for his business as they have been for the ever-growing craft beer industry.

Eagle Distributing isn't quite as old as Cherokee, coming into life in the early 1980s at the time of the World's Fair, when Tipton Distributing was purchased.

Bob Winkle serves as the company's general manager, and Steve Merrill works as the marketing director. They've been at it side by side nearly the entire time, having seen the beer industry—and the craft beer segment it currently contains—go through many changes.

In the beginning, Winkle said, there were no craft beers, just a few imports, like Heineken and Molson, but what Eagle was doing then was completely different than what it is today. It was exclusively distributing for Anheuser-Busch, which is still the largest brewery on the planet under the name of AB In-Bev. The partnership lasted for a few years, but through some legal fancy footwork, Eagle loosened the financial grip around its neck and broke free.

The times have changed dramatically in those thirty-five years, with a big craft beer revolution taking place right under Eagle's nose. It was SweetWater Brewing Company that gave Eagle its first official taste of craft beer, even going as far as being in the running for the "wholesaler of the year" award, which would string together consecutive years of it being one of the leading distributors in the nation.

"We've got a good chance at winning that, which is a nice compliment," Merrill said. "We were nominated for it last year, and they [Sweet Water] are our largest craft supplier right now."

Eagle distributes for the likes of larger craft beer companies like New Belgium, which brews out of nearby Asheville, North Carolina, these days. All the time, the company is trying to expand its roster of offerings the right way. It was through SweetWater and New Belgium that Eagle learned its way through craft beer, which has paid off as the market grows. In total, the company currently finds itself with thirty-eight beer suppliers in all, but craft has clearly continued to grow at a rapid rate.

More on the Johnson City side of the East Tennessee region is Holston Distributing Company, which splits the beer and craft beer distributing duties with Cherokee Distributing for much of the area's retail spaces.

Frank Wood is the president and has sent down through his ranks of administration a mandate of pride and community. Rarely does a beer-able event occur in Johnson City, Bristol or Kingsport without Holston showing its support. Downtown Johnson City's Blue Plum Festival—the largest in the region, with eighty thousand guests hitting the downtown

streets over the course of a weekend—is no different. Holston has been a bigger part of the fun than just an unseen sponsor.

When the festival added a beer festival—the Blue Hop BrewHaHa—in 2014, Holston didn't just want to make sure it happened, but it also wanted to become a staple of the event and a reason for Tri-Cities craft beer lovers to come out to be a part of the fun.

"Holston has been more of a partner than a sponsor," Jenny Lockmiller, a member of the Friends of Olde Downtown group that puts on the weekend event, told the *Johnson City Press* for the 2014 installment of the festival. "They were very supportive of our craft beer event. Holston really wants the festival to be sustainable and support itself as much as possible."

Holston also served as a proponent of the Tri-Cities Craft Beer Week, which began in April 2015.

In earlier years, the distributors weren't as hands-on. Distribution numbers around the state lines varied drastically. Jellico, on the Tennessee-Kentucky border, sold more beer to patrons from Kentucky counties northward than in Tennessee. Since most distributors in Knoxville were assigned territories and supply their customers by contract, it was

Working the bar in Johnson City. *Courtesy of Holston Distributing and Mike Hubbard.*

unlikely the customers would be able to shop for better wholesale prices in other Tennessee cities distributors were based in during the 1980s. Some retailers in neighboring Scott County were able to purchase case beer for some seventy to eighty cents less than wholesale price because they dealt with distributors in Chattanooga. Paul Naumoff, owner of Paul Naumoff Distributing, said that price increases are passed on to the wholesaler from the brewery.

5
REGULATORS AND THE REGULATED

The first vote in Knoxville for a liquor tax was in 1907. The second vote was in 1961 over package sales of liquor. The third vote was in 1972, when Knoxville voted on whether or not to sell liquor by the drink. The fight for legal liquor in Knoxville lasted from the turn of the century until 1972, and before it was over, it involved three votes.

In 1907, Knoxville looked at introducing a liquor tax to shore up funds for the city. A meeting at Market Hall occurred. The mayor stated that the city would lose $33,000 per year without the liquor tax. A committee was appointed to write a resolution for a later vote regarding how saloons could operate.

This left prohibitionists disillusioned, as they did not want saloons in Knoxville, arguing that for every $1.00 the liquor tax brought in, it cost the people $16.50. A vote ensued, and the dry voters declared victory. Knoxville remained dry until 1961. In 1961, the vote was taken to legalize package sales for liquor, and the wet voters won the battle.

In 1972, another vote was made to allow liquor by the drink, with the wets arguing it would bring an increase in tourism and tax revenue. The opposition argued that half of all accidents that occurred were due to liquor. In 1961, Knoxville approved liquor sales, and in 1972, liquor by the drink was approved.

For the fourth time since national repeal, Knox County rejected legal liquor in preference of continued prohibition. The rural region's opposition was overwhelming, while the city majority voted for legalization in 1955. The previous vote in 1947 showed only marginal change over that period.

Consumers Beer parade float—"We Deliver Beer"—in a Knoxville parade in the 1930s. *Courtesy of the Thompson Photograph Collection and McClung Historical Collection.*

If the consumption of alcohol had never taken root in the state of Tennessee, especially on the eastern side, it would be hard to imagine exactly what would fill out the newspapers, magazines and print publications.

With such a strong and pious movement against alcohol in the Volunteer State for so long, the topic, perhaps indulgent to read about for the alcohol opponents, always made for high-quality journalism. A survey of beer, wine and liquor articles from various eras shows that writing about this topic was a surefire way to sell the printed product. So much history was bottled up into these prohibition-era headlines, there was always something to say about the opposition, support and sometimes insanely bizarre laws that surrounded alcohol legislation.

In 2009, *Metro Pulse* dedicated "The Drinking Issue" to "Alcohol, the Law, and You!," which was a comical and historical look at some of the interesting and downright crazy state, county and local laws

that had made it onto the books. As noted in the August 20 piece by Charles Maldonado, Knoxville found itself ahead of the curve in regard to prohibition; the city beat the nation to the (rum) punch by twelve years. Because some of these laws have not been repealed the same way prohibition was, the author warned his readers that even in 2009, some of these prohibition-era regulations might still be the law of the land, and readers could be guilty of breaking one or many of them.

In a handy flowchart that accompanies the hilariously apt and able article, put together by *Metro Pulse*'s Matthew Everett, it's well explained just how and why someone might be breaking a booze-related law. For example, in the restaurant- and bar-filled city of Knoxville, you're shit out of luck if you want to buy alcohol on a Sunday or a holiday, or on any day between 3:00 a.m. and 8:00 a.m. You can only purchase Monday through Saturday between 8:00 and 3:00 a.m. if you're at a bar or 8:00 a.m. and 11:00 p.m. if you're having a couch day and simply want to buy some wine or liquor. One

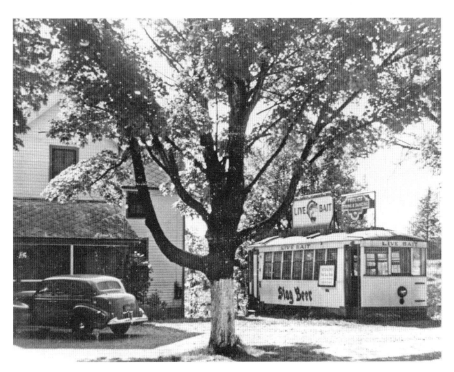

Stag Beer and Fishing Bait, a combination made for the ages in a converted streetcar in the 1940s. *Courtesy of Knox County Two Centuries Photograph Collection and McClung Historical Collection.*

minor easement of the aforementioned city of Knoxville beer laws includes an extra window between 11:00 a.m. and 3:00 p.m. to buy beer for those couch day Sundays when you don't want to put on a nice shirt to go to the bar for booze.

6
GONE BUT NOT FORGOTTEN

New Knoxville Brewing Company

In 1994, the New Knoxville Brewing Company name was revived. The company opened a brewery on East Depot Street, about eight blocks east of the original brewery, in the old Wallace Saw building. That iteration of the NKBC closed in 2000, lasting five years longer than the original NKBC. Ed Vedley came around in 2004 and reopened the NKBC, again in the Wallace Saw Works building. His go at reviving NKBC lasted until 2006. The building sat empty until Adam Palmer and Johnathan Borsodi came around in 2010 and began the Marble City Brewing Company. In 2011, the name was changed to Saw Works Brewing Company in honor of the building that housed Wallace Saw Works.

Sophisticated Otter Restaurant and Brewing Company

After three years of getting the Sophisticated Otter Restaurant and Brewing Company established, in 1995, Reed Tester, originally a server turned brewing assistant, took over as the head brewer. He learned under the original head brewer but quickly went on to develop his own style. The results were impressive, though the beers he was producing at the time on the five-barrel system were not getting the notoriety they would have today, with the much more mature local beer market.

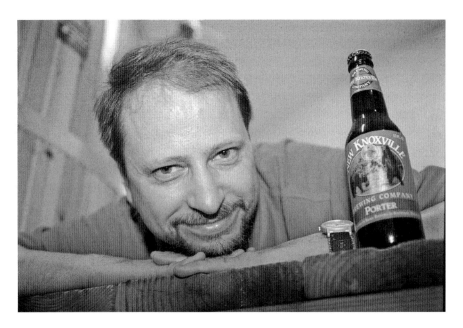

New Knoxville Brewing Company reincarnated, with the flagship porter. *Courtesy of Knoxville News Sentinel.*

When he was strutting his stuff brewing for downtown Johnson City's original brewery, there was really only one other local brewery, Depot Street Brewing, which was one town over in Jonesborough. And Depot Street used to get its yeast from the Sophisticated Otter.

"We were building something in JC that people hadn't seen before," Tester said. "At one time, we had a little movement toward craft beer going and all that happened. I'd say we were ahead of our time, a little." The "all that happened" Tester is referring to boils down to business. He said they had a wonderful staff on hand during the time he was there, and everyone was forward-thinking about both the brewery and restaurant side of things. Unfortunately, it all unraveled when staffing choices were made based on a new business model, sending their ambitious brewer away.

"We had really good support," he said. "We were making money. I just think that people, the people that opened the place were looking to build something up and sell it and get a good bit of money for it. They did, and the people that bought it after them, they kind of ousted me and put one of their owners in charge, and he didn't know as much as he thought he did from what I'd heard, and I moved to Denver after that."

A Fermented History

Now that he's back in the Johnson City area, Tester admits he looks at the success of Yee-Haw Brewing, directly across the street from the location he once brewed at, and wonders what would have happened if the structural support was there at the time he was and also if the general public was ready for what the Sophisticated Otter was putting out. From what Tester understands, the Sophisticated Otter declined after that and ultimately closed.

What the Sophisticated Otter had on tap was an array of beers, light to dark. It started its customers with a Honey Blond before moving them up to the Indian pale ale and, if possible, the One-Eyed Porter. Tester, a bartender with a knack for selling drinks, said they had good luck with selling flights, often starting their interested customers off with a sample of something before getting their hooks in and letting the beer do the talking. Even now, he looks back on the good times and gets a little pain in his belly thinking of what could have been.

"It's beautiful and it's so good for this area," he said. "Otter was just way ahead of its time. If we could open now, it would just explode. It was a good time back in the day."

Triple B Brewery

Jimie Barnette remembers it well. He was at his tent at Tennessee Oktoberfest in Kingsport, serving his Belgian Wit and doing what he loves to do: talk about craft beer.

"Is your Wit good?" he was asked by someone.

"I'd say it's as good as anything outside of Belgium and as good as a lot of them in Belgium," Barnette replied, not realizing that he was setting himself up for a challenge.

"I'm from Belgium," he heard from the line. And then it was on.

Nervously, Barnette pushed ahead a glass of one of his favorite beers and anticipated the Belgian's response.

"It's as good as any Wit in Belgium," the man said.

Though Triple B Brewery had not come to fruition at the time, with beer standoffs like this one, Barnette knew he had what it took to produce beer on a scale larger than homebrewing quantities. Fast-forward a few years, and Barnette's idea started in 2015 with Myron Woods.

It would be fair to say that Jimie Barnette is obsessed with beers from Belgium and Germany, which is somewhat odd because, he admits, when he

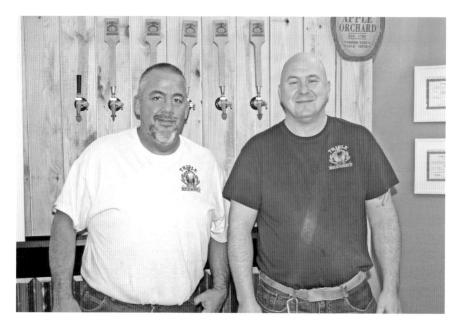

Myron Woods and Jim Barnette, co-owners of Triple B Brewery in Kingsport, focused their efforts on Belgian-style beers. *Courtesy of Tony Casey.*

found himself in that part of the world while in the service, he never really drank beers from those two countries—or beer at all.

Barnette's thinking was that he should see what it was all about. So, he went into a bar in Germany and ordered a beer, only to have his life change as soon as that hefeweizen touched his lips. "Never have I had a beer with that much flavor and aroma and just that good," he said. "That turned me into an ale lover."

Although Triple B Brewery closed in 2016, the passion for great German beer continues to live with Jimie.

7
BEER TRAILBLAZERS

In 1993, state senator Carl Koella sponsored legislation that allowed the first brewpub in the city of Knoxville. It was to be located at the corner of Gay Street and Summit Hill. It never opened. Instead, in the unlikely Woodruff's furniture location on Gay Street, the Smoky Mountain Brewery began brewing beer in a giant copper kettle.

In 1995, after the city's first commercial brewpub had opened downtown, the Copper Cellar/Calhoun's restaurant chain established a brewery on Bearden Hill.

Tried and True Knoxville Craft Beer

Brewery: Woodruff's Brewing Company (Downtown Grill & Brewery)
Where: 424 South Gay Street, Knoxville, Tennessee 37902
What's on Tap: Woodruff's IPA, White Mule Ale, Old World Porter, Downtown Nut Brown Ale, Downtown Blonde Ale, State Street Stout, Alt
First Pour: Late 2002
The Story: For all intents and purposes, the Downtown Grill & Brewery's Al Krusen is as important to the craft beer scene in Knoxville as anyone else.

The beer selection has an old world twist, with traditional styles that sweep across the globe, but walking into the South Gay Street location really drives home the point that Krusen and his cohorts are traditionalists with a fine appreciation for the development of traditional beer. That's not

Downtown Grill & Brewery, an institution and the home of Woodruff's. *Courtesy of Aaron Carson.*

to say they don't have fun with their seasonals, which the humble Krusen will boast about if pushed, but entering Downtown Grill & Brewery, where the Woodruff's Brewing Company is located, is almost like stepping back in time.

Aside from the floors, bars, tables, stools and décor made of finely polished hardwoods, directly behind an island bar is an impressive old piece of equipment: the fifteen-barrel Bohemian brewhouse that sits directly in the middle of the dining room, with the surrounding space still very much looking like the hardware store that filled it out for more than one hundred years.

Though he operates out of this dining room and restaurant, and has for more than a decade, Krusen did not cut his teeth on the Bohemian system. In 1996, he helped open up the New Knoxville Brewing Company, which eventually developed the building that would house Saw Works Brewing Company, which resides there today.

Having homebrewed as he worked as a forestry researcher for the University of Tennessee, Krusen moved on and found himself pretty well situated as a "happy stay-at-home dad" for a few years, when quality time was spent with his two-year-old son.

Following those few years of being more homebody than homebrewer, Krusen was turned on to the building that formerly housed the Smoky Mountain Brewery.

He started by brewing a few of his beers for the Downtown Grill & Brewery's taps, four of the eight available pours. Then Woodruff's blossomed from there until it manifested into its current spot, which has consistently, under his watchful eye and careful planning, pumped out delicious beer.

Considered by many to be one of the three godfathers of the Knoxville beer scene—along with Marty Velas, who now cranks out beer for Fanatic Brewing Company, and the Maryville area's Ron Downer—Krusen has seen the trends in craft beer come and go.

"Almost everybody I can think of has gone into it for the passion of beer," he said. "I've known people who went in with a passion for beer, who struggled until they attracted businesspeople who were willing to work with them. A passion for beer isn't necessarily a skill in business."

Krusen will keep seven of his tried and true beers on tap at all times and then add in one of his seasonals, with the brewmaster admitting he might not focus on the seasonals as much as other breweries. And that's basic economics for him; he says that the seasonals simply don't sell as well as the favorites.

Woodruff's Brewing Company's tap lineup, surely good for all that ales you. *Courtesy of Aaron Carson.*

"When you're a production brewer, you go for the same consistency, over and over and over again," Krusen said. "You don't experiment. You don't tweak it. You don't make changes at all. That's how I started in brewing, and that's what I do today."

The First of Its Kind in the Tri-Cities

Brewery: Depot Street Brewing
Where: 904 Depot Street, Jonesborough, Tennessee 37659
What's on Tap: Freight Hopper, Pullman Porter, Depot Express Amber Ale, Southbound Scottish Ale, Loose Caboose Lager, Roundabout Rye Stout, Eurail Gold
First Pour: August 2004
The Story: Just off the beaten path of Jonesborough—the oldest town in the state of Tennessee—you will find Jonesborough's first craft brewery on Depot Street. Owned and operated by Michael Foster since 2004, when the former physician's assistant and artist made the switch from homebrewer to brewmaster of his own domain, Depot Street Brewing set the stage for the modern craft beer boom in the region.

A Fermented History

Looking forward, Foster sees the Tri-Cities region—including Bristol, Tennessee (and Bristol, Virginia); Kingsport, Tennessee; and Johnson City, Tennessee—in the early stages of a craft beer upswing, an upswing in which his brewery has played a big part.

In the beginning, state laws allowed breweries to conduct business, but Jonesborough's laws were a different story, with no specific laws on the books. Though Foster faced no headstrong opposition, he tackled the rigorous process of writing new statutes with the town's lawyers, going through multiple readings and ultimately overcoming a mountain of paperwork and government-approved construction to be able to legally pour his handcrafted suds.

Recalling the process, Foster assured that he could do it much more efficiently if he had to do it now, but he was able to get from the point of having an idea, through pure willpower, to where he is now—producing beer for his loyal followers and having it enjoyed across the region's restaurants and bars.

Foster, who already had homebrewing figured out, jumped into this big project but said he sought out advice from breweries in Sevierville and Knoxville to get an idea about the equipment they used. And this is something Foster has reciprocated for other startup breweries looking for the same kind of information. He knows well what it's like to be starting out in the craft beer business.

At Depot Street Brewing, it's important to Foster and his fellow brewer Devin Rutledge not only how much beer is produced and sold, but also how it is enjoyed. Foster said the community welcomed them with open arms, and they decided initially to self-distribute. Though they decided to cease their self-distributing ways after a few years, the process taught them valuable lessons about the entire business. Actually going to the businesses that hold their accounts gave Foster and Depot Street Brewing a better sense of what is important to the people who sell their beer and, ultimately, the people who drink it.

"I initially started off self-distributing," Foster recalled. "We learned what that entails—going to the accounts and cleaning the lines and meeting the people and developing the personal rapport. After a while that becomes too time consuming as your area gets bigger and bigger."

Near the beginning of its journey, Depot Street Brewing found itself in an interesting spot, in the middle of Jonesborough—a town known for its patriotism and respecting the old ways. Seeing their surroundings, the people at Depot Street Brewing worked to make sure they presented their

new business in the most respectful way possible. Going at it with a goal of acknowledging and working concurrently with the town's heritage, Foster has given area beer lovers a place to relax, socialize and—most importantly to Foster—be a part of his and Jonesborough's extended family.

Because beer and Tennessee railroad history is rich in Jonesborough and the Tri-Cities and trains move directly next to the brewery's outdoor area, Depot Street Brewing makes tracks and beer a working relationship.

Members of the Watauga Valley Railroad Historical Society and Museum told Foster that he can expect the passage of twenty-six trains per day just behind his bocce ball court, but it would be hard to expect them on any kind of schedule. The good news, from Foster's perspective, is that the trains don't sound off their horns until they've gone by the brewery and move closer into the downtown area, so he only sees the benefits of passing trains. People love them, and the artist in him loves to see some of the graffiti art that graces the sides of the train cars.

Depot Street Brewing's family includes people from different groups in the Tri-Cities community, and Foster takes pride in having a social hangout for all walks of life. With the reemergence of breweries as local binding agents for like-minded people, Foster said he sees this as a throwback to times of old.

"Before prohibition, every community had their brewery," Foster said. "There were four thousand breweries. We're just now getting back to that. We're getting a lot of big ones, of course. I think that's the way it should be. I think every community needs their own brewery, and it should be a local business."

Though Foster won't take any credit for making Depot Street Brewing the first of its kind in the region—saying that another would have come along eventually—he admits to taking pride in his journey of starting fresh all the way to bringing his business to the point it is at now. Offering a full bocce ball court behind the brewery, as well as tables and chairs surrounding the two chimeneas, Foster said he enjoys seeing people come together. Depot Street Brewing is a place where friends can come and share a conversation with each other, but it's not by accident that bocce is a game where the first rule is that players introduce themselves to one another, forcing everyone involved to familiarize and become more social, increasing the chances of friendships being made.

"That's what we want to do here," Foster said. "We don't just want them to come and sit with their friends all the time and be isolated. You need to interact. People want to meet other people; they're just shy. So we give them a reason."

A Fermented History

Bites and Beers Always Available at Smoky Mountain Brewery

Brewery: Smoky Mountain Brewery
Where: Turkey Creek, Gatlinburg, Maryville and Pigeon Forge
What's on Tap: Mountain Light, Velas Helles, Cherokee Red Ale, Tuckaleechee Porter, Black Bear Ale, Appalachian Pale Ale, Windy Gap Wheat Beer
The Story: Smoky Mountain Brewery's story is different than many of the others in this book in the sense that it's had no problem expanding on its success. With four locations across East Tennessee under the Copper Cellar Restaurants group, the highly crafted beers are available in several different varieties of restaurants.

Chief operating officer Bart Fricks says the company offers everything from a barbecue joint in Calhoun's to a steakhouse in Copper Cellar to Chesapeake's, a seafood restaurant, all of which serve Smoky Mountain's beers.

The brewery has taps at each restaurant, but what you won't find are guest taps. "All of our beer supplies are in the restaurants," Fricks said. "You can't go into any of our restaurants and get Bud Light on tap or somebody else's microbrew. You get our beer."

Fricks calls his restaurants "high-volume" in that his team of brewers is always trying to keep up with the demand for the beers on tap and nothing more. And the restaurants are the only place you can get Smoky Mountain Brewery beer. "They drink a lot of our beer," he said. "If we didn't have the restaurants, we could produce enough beer to put it out to retail accounts, but you only get our beer in our establishments, and I think that's what makes us different than a lot of places that are just production facilities." He doesn't consider the four breweries to be production breweries for that reason.

As a pioneer in the East Tennessee area, Smoky Mountain has been brewing its own craft beer for about a quarter of a century.

Giving the nod to owner Mike Chase, Fricks said it was the boss's idea to brew for the company so long ago, and it's obviously paid off with the growth and popularity of the brand. Fricks isn't shy to boast about this popularity. "We're a very predominant player in the restaurant industry here in East Tennessee, and it's just a great natural fit or a natural marriage to have a naturally produced product that people can consume, whether it's our great food or our beer," he said.

He also boasts about the pair-ability of the company's beers and food offerings: the IPA with a hand-tossed pizza or just about any of the beers with a big, juicy steak.

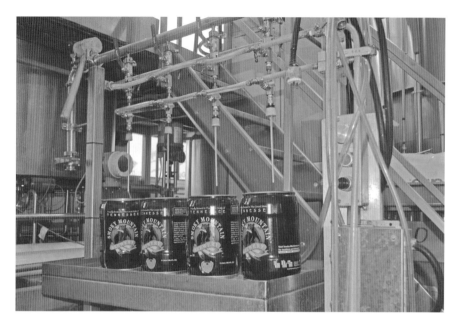

Smoky Mountain Brewery's mini kegs being filled. *Courtesy of Aaron Carson.*

Dr. White and his South College brewing class take a minute to pause for the cause. *Courtesy of Rob Shoemaker and* Tennessee Craft Beer Magazine.

A Fermented History

Plus, that's not just Fricks talking—that would be the judges of national contests. It's important to note that the company's beer and food have been of award-winning quality. Some of the beer offerings include the Mountain Light, Smoky Mountain's most popular beer; Velas Helles; Cherokee Red Ale; Tuckaleechee Porter; Black Bear Ale; Appalachian Pale Ale; and Windy Gap Wheat Beer. And those, of course, go along with a wide array of seasonals.

The restaurants do have a great deal of regular customers, but they also have a lot of walk-ins and people very new to craft beer. To make matters even more local, the four brewmasters have all come out of South College's brewing program over the years, with one having been with the restaurant family for more than ten years.

8
CRAFT BEER ADJUNCTS

Craft Beer Gets Business Booming (Adjuncts)

The brewers aren't the only ones benefiting from this East Tennessee craft beer boom, as businesses on the periphery—often working with the brewers themselves—are finding themselves busy keeping up with demand. Beer tours, brewery equipment manufacturers, beer glass makers and more have sprung up around this movement.

The Pretentious Beer Glass Company, along with owner Matthew Cummings, is the most acclaimed hand-blown glass company in the United States. *Courtesy of Aaron Carson.*

Of course, places that serve and sell beer have done well with their tap options growing. Some breweries have decided to self-distribute their beer and need available taps to pour and sell their brews from, and retail locations in Knoxville, Johnson City and everywhere in between are shaping up to be the perfect places for beer to be discovered and enjoyed.

Those who use a wholesale distributor also benefit from having their products on shelves across the region. Whether in bottles and cans or representing from a tap handle, both brewers and the places that sell their goods make money on this commerce.

The Industry

Bubba's Barrels

You could go bigger than what Carl Clements offers for his beer equipment. Many manufacturers across the country and overseas supply large breweries with their brewing and fermentation systems, but few can match the unique way Clements produces smaller-scale equipment for aspiring head brewers.

Clements, the owner and founder of the Knoxville-area Bubba's Barrels, began the company simply because he couldn't find anyone else offering what he was looking for. At the time, this was wholesale-priced fifty-five-gallon drums. They were extremely difficult to find in small quantities, and he found that unfair to the little guys like himself who don't have a use for that many.

Finding the one he needed, he went on to buy two more, then three more and so on. He quickly found himself becoming the guy who could supply the little guys with fifty-five-gallon drums if they needed one.

Enjoying a fine pint or building a new creation, Carl began manufacturing smaller-scale brewing equipment for those brewers who are making the transition from homebrewing into owning a brewery but aren't interested in fifteen-barrel systems.

Clements has found there to be quite a market in this booming industry in those transitional brewers looking for not only American-made, but also Tennessee-made, brewing barrels, all with the guarantee of the best hands-on customer service available.

"I provide something that is price competitive with import products that is domestic," Clements said. "I'm pretty easy to get a hold of to talk to. That's

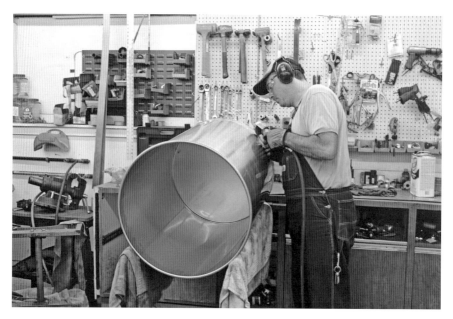

American-made Bubba's Barrels being crafted and built by hand. *Courtesy of Aaron Carson.*

not something that most of the people that import really understand, how their stuff's made."

In Knoxville, the Tri-Cities and the Southeast, he's got quite a loyal following of breweries that are making their craft beers on his equipment, but while the Southeast is good to him, he says Pennsylvania is his number one state, oddly, and it's a sign that he's having trouble keeping up with the demand for his converted and in-shop welded brewing equipment.

Two to three companies in the United States sell the same kind of stuff he does, but the difference is, they're importers. With import products, the goods tend to be cheaper, coming from parts of the globe where labor rates are lower. And though Clements employ around six full-time workers in Knoxville, all at a good wage, he can keep his prices on par with those import companies. Clements takes pride in this and being able to keep his customers in the three- to seven-barrel range happy.

A Fermented History

The Education

South College Professional Brewing Science Program

If you ask the owners of the breweries across the region, many would certainly give Dr. Todd White a thumbs up for what he's been able to do with the South College Professional Brewing Science program. That's because White, director of the program and decades-long craft beer lover, has produced many of their head brewers, assistant brewers and other professional brewers-to-be, starting the journey in 2013. Certificates in hand, more than forty have gone through the program.

When he was teaching at the college in 2010, White remembers seeing the tides changing and craft beer becoming more popular again and wondering where all the skilled brewers were coming from. Of course, some had trained under other head brewers, but that line had to start somewhere.

There was the Siebel Institute in Chicago and a similar program at the University of California–Davis but nothing in the Southeast. To get South College's program up and running, he needed to do some convincing. First, he started with Marty Velas, who is a godfather of craft beer in East Tennessee (and globally).

Velas was down with the plan and acted as an advisor along the way, and once they talked the school into allowing the program, they were off. "We're a two-quarter program, a six-month program," White said. "We graduated the first class in March of 2013. We graduated three classes, forty students, and got like a 90 percent employment rate. I'm getting phone calls and e-mails from breweries I'm in contact with, calling me, telling me they've got jobs."

His priority to the school, students and program is to get everyone enrolled a proper education, which will most likely land them a job with a brewery or something like it in the industry. Internships with Depot Street Brewing, SweetWater Brewing Company, Highland Brewing Company and many others in the Southeast region have boded well on the résumés of his students, lots of those connections coming from White's relationships with those breweries.

"I feel like that is part of my job is developing these relationships with these breweries to let them know what we're doing and how they can help us and how we can help them," he said.

Typically, White's students have been men in their mid-twenties to thirties years of age, but he's also seen more women take interest in the program and go on to score those post-program brewing jobs, too. Many

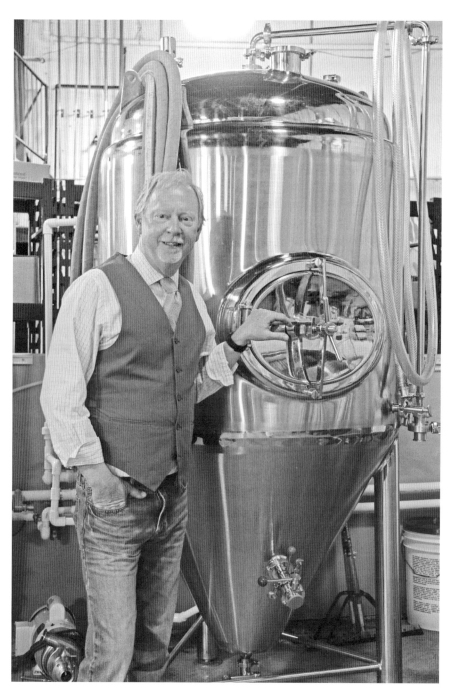

Dr. Todd White helped found the South College Professional Brewing Science program. *Courtesy of Rob Shoemaker and* Tennessee Craft Beer Magazine.

of those who go into the program are homebrewers. White figures that number is about 75 percent, and the remaining, maybe surprisingly, are people aiming to learn about brewing for the first time. And the course is structured to do that.

Structurally, White brings his students through sections on chemistry, biology and mathematics before letting them really get hands-on with brewing. As much as making it through the program has been fruitful in terms of jobs placement, the most important factor White sees in measuring a student's possible success in the craft beer and brewing industry is the same as in other industries.

"First and foremost, it's work ethic, like any other industry," he said.

The Ingredients

Kings Family Hop Farm

The western United States currently has hops on lock down, with brewers from all across this expansive country buying this most vital beer ingredient from that region and that region alone.

Brant Bullock, who lives some few thousand miles away from that half of the country in Piney Flats, Tennessee, admits he has a problem with that. Of course the cultivation of hops is better in a certain climate, which gives the West a bit of an advantage, but Bullock says and proves that quality hops can be grown and cultivated elsewhere, too.

He does just that on his King Family Farm, which is on a rather historical piece of land, going back to its beginning—on the books at least—as a piece of a four-hundred-acre tract of land owned by the State of Franklin, which temporarily seceded from the United States in the mid-1780s.

The land sits just off the Rocky Mount State Historic Site and has been in Bullock's family for nearly all that time, and he wants to see the property used in the way he sees fit. "There's a lot of history there, and I didn't want to see it disappear, so we worked really hard to acquire the property and be able to continue its agricultural history," Bullock said. "It sat dormant for some years and of course passed down through family and so."

Currently, Bullock, with his wife, uses it to raise heritage breed animals and do a lot of farming crops. They do quite a bit of breeding with pigs, chickens and other poultry. The hops, he said, is something they want to add to their community, specifically to build more community and commerce

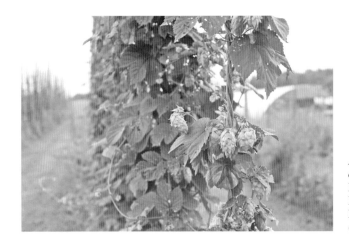

A trestle line's worth of hops hangs at Brant Bullock's King Family Farm in Piney Flats, Tennessee. *Courtesy of Tony Casey.*

with the area's brewers. There are nearly ten brewers in a fifty-mile radius of Bullock's hops, which were grown on rows of trellises throughout 2015.

Wet hops, those plucked directly from the vine, are where Bullock sees the most local potential. Time is of the essence with wet hops because, typically, they need to be used for brewing within twelve hours of being harvested or else the drying process will begin.

The aroma, though, is well worth the somewhat lower level of convenience. Bullock, a homebrewer of many years, says wet hops are greener and more unique in scent than anything he's come across. This has to be appealing to local brewers, who are sick of bringing in their dry hops from across the country and having such a large component of their local craft beers come from not-so-local places. Bullock said it's not uncommon for some brewers to overnight wet hops from the West Coast so they can brew with them.

This is where Bullock fits in. He wants to work with the brewers to develop hops they can use in the brewing process. Drake Scott, former head brewer at Wolf Hills Brewing Company in Abingdon, Virginia, used his wet hops for special brews, and it's as easy as Bullock picking the hops himself and delivering them by noon to give brewers like Scott a chance to get in a full day of brewing with wet hops.

That's not to say Bullock doesn't offer dry hops. When in season, it's common that he'll pick and pelletize amounts larger than fifty pounds in a day. He can vacuum pack the hops, freeze them and have them ready whenever needed, saying that they're a bit easier on brewing equipment than wet.

He envisions locally hopped beer taking off soon and being able to keep up with demand. With only a handful of other hop producers in the immediate East Tennessee area, he could be hopping on to quite a good

idea. Because those western United States hop farms are so greatly affected by changing climates, there can be shortages and subsequent delays in shipping, so brewers around this region might consider Bullock's operation for that reason alone.

Hellbender Hops

There's a movement in the Southeast region of the United States to grow hops—an absolutely integral element to the beer-making process—and in Knoxville, the work is being done at the Hellbender Hops Farm. Trent Gilland is the man who sets up the trellises and grows hops for his East Tennessee brewers.

The year 2015 was what the Hellbender Hops Farm considered a light year in regard to its crop yield, but it was still able to make available to its brewers Cascade, Mount Hood and Chinook varieties. These three names have significance in the Northwest. The Cascade Mountains in Washington and Oregon contain Mount Hood, and chinook is a variety of salmon found between California and Alaska. Hellbender clearly isn't trying to reinvent the wheel as much as make hops readily available to brewers in the Southeast, too.

In a mid-June 2015 interview with the *Knox Mercury* magazine, Gilland spoke about what it meant for him to make a career switch into hop farming, something that's always been a passion of his.

He is a beer man and a foodie of sorts but told the magazine's S. Heather Duncan that he felt the the hops business was much more accessible than the brewing industry, which is seeing such a boom. Fighting those kinds of numbers would be difficult compared to the few who are tackling hops farms. "If I'm a brewer, even if I'm great, I've got to beat 2,000 other people," Gilland said. "But if I grow hops, I'm in the game from day one, and I'm guiding the beer."

Instead of competing with those brewers, he's working with them to help put out a locally sourced beer. The process is arduous, he admitted. Even in a down year, he's pulling more than 500,000 hops. To do this, he takes down the prickly vines and starts picking away at them rather quickly as they need to be tended to immediately. Luckily for Gilland, it's not just his hands that are busily working away at the fruits of his one-acre plot of land. Because he's a beer and food guy, the same can be said about the company he keeps, and with a solid work-bribe of beer and food, he throws a picking party with all his friends and family, knocking out a chunk of the labor.

Michael Landis, Cheese Man

As more craft beer aficionados are saying "cheese," Michael Landis stands above the rest for East Tennessee brewers. He lives, breathes, sniffs, judges and certainly eats cheese for a living and works with beer people all over the United States and world to make sure they have the proper cheese for their events.

Beer and cheese pairings are rising in popularity, much like traditional wine and cheese parties. Landis, who spends a great deal of his days dealing with craft beer, calls it "liquid bread," which goes so nicely with many of the available cheeses out there.

Often, you will find Landis at craft beer festivals across the country, educating beer people about this extra important additive to the beer scene. Landis operates out of Tampa Bay, Florida, and serves as a training and merchandising manager for Gourmet Foods International and generally as a travel expert on cheese, wine and beer, even serving as a world cheese judge in 2010 in Birmingham, England.

To say he knows his cheeses is an understatement. And if you'll excuse the pun, his vast knowledge of this international food is why so many brewers, festival producers and more want to pair up with him. Take Erich Allen, for example. He's the brewmaster for Studio Brew in Bristol, Virginia. He and Landis met each other at the Great American Beer Festival, where Landis was speaking. Since then, their friendship and collaboration opportunities have blossomed.

Because Allen is adventurous with the brews he churns out, this caught the eye of Landis, who had him down to his place in Florida. After a few days of not brewing, Allen got the itch, and he and Landis teamed up to make their Mischievous Ale, which was a hit at East Tennessee's 2015 installment of the Thirsty Orange Brew Extravaganza.

At that very festival, you could find both Allen and Landis, side by side, discussing with festivalgoers the ins and outs of the beer they brewed together, as well as the cheeses Landis brought to pair well with the available pourings.

The Firestarters

Knox Beer Snobs

As the saying goes, if you love something, share it with the world. Rob Shoemaker, co-founder of the Knox Beer Snobs, does exactly that.

A Fermented History

Shoemaker knows the ins and outs of Knoxville craft beer better than just about anyone, and he's written extensively about the many, many glasses of beer he's encountered and enjoyed on his uber-popular beer blog www.knoxbeersnobs.com.

The tagline used by Shoemaker and his fellow co-founder, Don Kline Jr., sum up exactly what they do. "We're just two beer lovin' guys in the Knoxville, TN. area that love beer and all that goes along with it," they boast. "The craft beer market is booming and Knoxville is finally starting to see the fruits of this growth."

The blog came about under Kline and Shoemaker in 2010 at the same time as the Bearden Beer Market, which was a catalyst for area beer, too. "Snob" was a term that was applied to their general unwillingness to drink boring beers out of a can.

When the two found themselves traveling out of the area and bringing back all the different beers they were trying from around the Southeast, they found themselves suffering a good problem for a couple of beer snobs. They were losing track of all the beers they were trying, and that's when it dawned on them to use the blog as sort of an archival project. It took off like that, and the brew-loving duo found themselves gaining popularity with their words as the local area around them began to boom with a love of craft beer.

They continued to write blog posts on everything from announcing release parties to breweries to the pertinent information related to festivals. Out of their enthusiasm came the Tennessee Beer Week, which had been done across the country and deserved proper replication—with an East Tennessee twist—in the Knoxville area. This has been going on for nearly five years, holding on to the same model that has key beer-related events taking place throughout a week, highlighting the best of the local craft beer scene.

Jeremy Walker, now with Johnson City's Yee-Haw Brewing Company but then with Eagle Distributing, helped kick things off with his accounts, getting them involved with the week's activities. "He didn't have a place to advertise it and had no central website," Shoemaker said of Walker's efforts. "So, he and I know each other pretty well, and he asked if we could put this up on Knox Beer Snobs. I said sure. I wrote about what this is and this is why we should support it. I was getting inquiries from businesses, asking how they could participate. News channels were asking what it was and if they could talk to us about it. It was interesting how it blew up."

The Knox Beer Snobs have been extremely successful at drumming up support for anything beer related in the Knoxville and Tennessee-wide markets, gaining the respect of their peers and the people they're helping to

promote. Shawn Kerr with the Brew Mob, a self-proclaimed collection of hardcore beer lovers, who also represents the Blount County Home Brewers, gave a nod to the beer snobs as opening doors for those involved in Knoxville-area beer in terms of beer law. "I'm most excited about the culture and getting these breweries open," Kerr said. "The toughest thing is because of the laws, when we're watching the other breweries open up to the United States."

Knoxville's doing that, too, with breweries popping up all the time, reaping the benefits of an eager set of bloggers who continue to promote what they do.

Homebrewers Reign Supreme

East Tennessee owes much of its status as the undisputed capital of craft brewing in the state to the homebrewers who laid down the foundation. Without the community, support and camaraderie of homebrewers, many of the existing commercial brewers wouldn't exist. An abundance of homebrewing clubs have continued to spring up and act as a feeder system for the next great East Tennessee brewery. Clubs such as the Blount County Home Brewers have been around for years, opening their doors to novices and experts alike. The Tri-Cities Brewers Alliance has continued to expand its membership with quality education and brewing. The Overmountain Brewers Club is a regular on the festival circuit, with a community approach to brewing. There are many other homebrew clubs in the region, too numerous to name, but all have made their mark on the East Tennessee beer scene. Whether starting out of a bottle shop or just two dudes, homebrewers continue to make their mark.

Tennessee Valley Homebrewers

To say the Tennessee Valley Homebrewers are an integral part of what's happening in the region in regard to craft beer just won't do them justice. More than one hundred members collectively make up their ranks, some as part of smaller brew clubs, but what might be most impressive about the organization is how much of the map it takes up.

The club members cover more than a forty-mile radius surrounding Knoxville, where they're based, and though there is great distance between members, through the magic of modern technology—more specifically an actively used e-mail list—they keep in touch with one another well, discussing any issues or bright ideas they might have. Out of these communications

Left: The Tennessee Valley Homebrewers is a collection of like-minded, craft brew–loving people in East Tennessee. *Courtesy of Sheri Hamilton.*

Below: Award-winning Chisholm Tavern is a staple in the homebrewing community with its famous Misty Melon Kolsch. *Courtesy of Sheri Hamilton.*

come "emergency" meetings, as needed, where pints are enjoyed and brewing exploits are discussed.

Experimentation is absolutely the focus of what this collection of brewers does. They share challenges within the group, where the same recipe will be used by as many as fifteen members, to see how individualized they can get from a standard practice.

Of course, food and informative get-togethers constitute a large chunk of their time spent together, with scheduled regular meetings and a pig roast. Within their ranks, they boast award-winning brewers and, they hope, award-winning brewers-to-be.

Dennis Collins and John Peed carry with them accolades from the National Homebrewing Competition and Master Championship of Amateur Brewing. Paul Hethmon, who is credited within the group for overseeing pig roast operations, also competed in the ProAm division of the Great American Beer Festival with Smoky Mountain Brewery.

The group is also a large part of the annual Knoxville Brewers' Jam, having the largest tent at the festival and being responsible for organizing key aspects of the festival and beer distribution during the festival day. They're always interested in more people joining in on their fun, which they feel is indicative of a growing craft beer scene in the region.

State of Franklin Homebrewers

The State of Franklin Homebrewers also have quite a bit of fun in the northeastern corner of Tennessee, with frequent meetings and active internal and external communication. Located in Blountville, this collection of homebrewers welcomes new members of all knowledge levels when it comes to education. The group's policy is, if you want to be a member, you can join.

"Yep, that's what our ultimate goal is—to enjoy the camaraderie among friends, brewing beer, discussing beer, sharing beer, get the picture? Come on out to a meeting—I'm sure you will enjoy it and want to come back," the group shares on its official website.

And who wouldn't want to join? The group is extremely welcoming and has great parties. St. Patrick's Day and Christmas parties are the biggest, but members also make sure to go camping on the Nolichucky River each year.

Between its fifteen members, it has totaled more than seventy-five years of knowledge, and the members are just itching to pour out that know-how with anyone who will listen and drink with them. Medal winners from homebrewing competitions can be found within the group's ranks, and it is always looking to hook up its most knowledgeable beer minds with the least. If progressing in the world of craft beer is the goal, then look no further than the work the State of Franklin Homebrewers have been able to do in regard to Erich Allen, whose Kingsport and Bristol, Virginia locations are changing East Tennessee craft beer.

Overmountain Brewers and Tri-Cities Brewer's Alliance showing the power of homebrewing. *Courtesy of Sheri Hamilton.*

Allen actually refers to his experience with this particular homebrewers club as a religious one because he was previously unaware that someone could make something as delicious as the beers he was trying at the meetings. This was the catalyst that shot him directly into the small-business world of craft beer. He immediately wanted to experiment more with beer and then share his crafty creations with others. But none of that would have been possible without the State of Franklin Homebrewers.

The Tour

You don't always have to replicate the wheel to be successful, and Knoxville's Zach Roskop realized that about two years ago when, after years of studying and being a part of the area beer scene, he felt like it was matured enough to welcome a business that offered brewery tours. Few people know the scene as well as Roskop, and he recognizes that he's the right man to tour his guests from brewery to brewery for the Knox Brew Tours.

"I'm someone who's very connected to the craft beer community," Roskop jokes. "And by connected, I mean drinking a lot of beer. You know what I mean."

He was in a band that was coming to its demise, and he was planning the next stage of his life when he and his father came up with the idea of purchasing a bus and driving people around, filling them with craft beer and the history that goes along with it.

Moving into its second year, Knox Brew Tours continues to grow and add more brewery stops as they continue to open up. Being so ingrained in each of them, having earned that behind-the-scenes access that most brewery visitors can't get anywhere else, Roskop offers an in-depth look at the businesses that's second to none.

Currently, it appears as if there will be seventeen breweries opened in the near future, all with individual stories to tell and beers to share, so as great as it's looking for the owner of Knox Brew Tours now, the future is looking even better. "We started ahead of the game on purpose, because we wanted to take advantage of being known as the first," the owner said.

The city's history is gone over in detail on his tour, including information about its Marble City past, harkening back to the early 1900s, when that was a material it became known for exporting. To transport his guests, Roskop uses the now-famous 1990 GMC bus named Kathy to deliver twelve to fourteen people at a time. It's stocked with LED lights; a cooler, of course; and a lock box to secure valuables.

Roskop's isn't the only operation in town, technically, as the Beer City Bus Tours makes its way over from Western North Carolina. Beer City Bus Tours does longer trips, hitting up Asheville from either Johnson City or Knoxville. Roskop also has his eyes on the Tri-Cities as an expansion of his Brew Tours.

The Glass

Pretentious Beer Glass Company

There are currently 1.5 million sellers using the website marketplace Etsy to sell their goods. At one point, Matthew Cummings's Pretentious Beer Glass Company earned itself a second-place ranking on that site, again of 1.5 million sellers. That staggering statistic should be enough to let you know that the man knows how to create high-quality things with his hands.

A Fermented History

As a beer man, and initially setting out to provide the world with his high-end pieces—all made with the goal of giving the beer drinker the best possible beer experience—Cummings made the obvious jump from making containers for craft beer to also producing what's inside the glasses.

It began with the glass company getting started in 2012 in Louisville, Kentucky, after Cummings earned his master's of fine art and was working full time in a gallery on big, one-of-a-kind pieces. The artist himself saw bigger things in his future and decided to change the course of his work.

"The sales are very sporadic on that," he said. "It's really feast or famine on that. You'll have a really big sale, and then you won't have anything for a while. There really is a selling season and there's a few months where you don't sell anything."

So over a few beers, Cummings, with the input of some of his buddies, decided to put his know-how of glass blowing to work, literally. First, he designed a glass to get the most out of a hoppy beer, which has since developed into a tailored glass. Customers can go to Pretentious Glass in Knoxville and get a custom-designed glass. Talk about hands-on drinking.

With his bottle share buddies, Cummings also opted to make each of them their own tailored glass. When drinking from these glasses, closely analyzing the craft beers they'd put in those receptacles, someone made the comment, "This is so pretentious." And the name has stuck ever since.

Now, Cummings offers the following models: ale glass, aromatic beer glass, artisan glass, dual beer glass, imperial glass, limestone glass, malty beer glass, Sauvin glass and Subtle beer glass. These all accomplish the duties needed by each beer put into them.

Cummings admits he has fun doing it and also that business has been good, but he also talks about the functionality of a beer glass specifically made for the beer it will hold. "The most brief explanation is any glass you pour beer into is going to affect the flavor of it," he said. "It's going to enhance or subdue certain aspects of the beer." So he's always planned carefully. His first set of glasses came about after an initial six months of research, carefully designing each.

As he moved to Knoxville and opened up shop, he's become even more popular, not easily able to keep up with the demand of his Etsy customers, but with the addition of his shop's extra space and a new plan to make his own beer under the same brand name, things are looking up.

Cummings is planning on pouring beer from his taproom in 2016. From that very room, he plans on doing some funky beers: sours and lots of Belgian-American hybrids.

The Bottle

Bearden Beer Market

BBM are the three letters that represent one of the original joints in Knoxville to get craft beer and chat with other beer lovers. The Bearden Beer Market is a beer store and place where taps are pouring pints 365 days a year. It was founded by Chris Morton, one of the catalysts of the area's craft beer scene. From the store, Morton and his employees have launched their own brewery and a thriving beer following and community.

In 2010, Morton began his journey as the famed "employee no. 1" of the Bearden Beer Market, and through conversations with "employee no. 2" and "employee no. 3"—Adam Ingle and Ben Seamons, respectively—the idea of opening a brewery out of their market emerged.

All the while, Morton, who'd previously worked in alcohol sales, was often cutting out the middleman, cold contacting brewers and getting their beers directly onto his shelves. These shelves were getting fuller, and their contents were becoming products with ever-growing demand. BBM was supplying the oddball and disorganized beer lovers of the region with the craft beers they previously had difficulty getting.

The Bearden Beer Market is one of the catalysts that set off the craft beer craze in Knoxville. *Courtesy of Aaron Carson.*

A Fermented History

Rob Shoemaker, one of the founders of the famed Knox Beer Snobs blog, which also began at the same time that BBM did, took notice of what the market was proving in regard to what beer lovers in the area wanted.

"When the Bearden Beer Market opened up," he said, "that's when the local culture here said, 'Hey, there's more to this beer thing here than what we're seeing on the grocery store shelves.'"

Shoemaker wasn't the only to take notice or take his money so frequently to Morton's spot to spend on craft beer. The wheels started turning again, and the homebrewers all across the Knoxville area who hadn't quite had their "eureka" light bulb moments yet admit it was after the success of BBM that they first considered moving from homebrewer to brewery owners and operators.

Morton remembers his beer-loving friends leaving Knoxville to go to Asheville, North Carolina, to spend their money. Frankly, that pissed him off, but through the development of the beer market and the massive number of breweries that opened up, there's good reason for these like-minded people to stick around.

"That is to make Knoxville really great," he said. "I want people from Asheville to come over here and spend the day. There were a lot of talented people leaving Knoxville to go and spend money. I don't want that to happen. This place is badass, and it's just now starting to really pop."

Libation Station

Joey Nichols, owner of the Johnson City area's Libation Station, started rather small, but he plans on finishing in a big way. As a one-stop shop for craft beer lovers, Libation Station was small and much less filled with delicious bottles of beer when it opened in 2005. The problem wasn't gumption or enthusiasm on the part of Nichols as much as it was very few options in regard to what he could sell his customers.

Highland Brewing Company out of Asheville was the only one that struck Libation Station's owner as a brewery that he could readily get for his customers. Most often, the beer he was getting in those beginning years was, like Highland, coming from North Carolina. For business to move in the direction Nichols sought, the options needed to expand with the tastes of his customers.

"It's education and bringing people together and making them aware," Nichols said of the first mental shift that occurred when he slowly trickled

Johnson City's Libation Station offers its loyal followers various kinds of craft beer in the form of singles and six-packs up to kegs. *Courtesy of Tony Casey.*

in whatever was available. "As distribution and the product offering has improved, so has the market. And it's been a nice trend over the last five years."

Within the plaza Nichols oversees, there's the Ligero Cigar Lounge in the same space and the Plaza Package liquor store directly adjacent to Libation Station.

Things drastically changed for Nichols and his customers in 2016, when wine began to be sold in grocery stores—one way Tennessee has decided to stay caught up with its neighboring states. It will be a trade off, with the business owner losing some business but gaining some, too.

Currently, any beer with an alcohol content of higher than 6.2 percent has to be sold in the liquor store, but when the law changes on January 1, 2017, Nichols knows exactly what will happen.

"When the laws change and we can get high gravity and we can get those bottles over here, this will be the true vision of what we wanted it to be ten years ago," he said. "Which is a true bottle shop. There won't be any high gravity over there. This will be a true bottle shop the second that law changes. I already have it all planned. The breweries are going to come, and there will be a lot

more to offer, as you well know. They're not going to deal with two different kinds of distribution. It's too much, but when it opens up, it's going to be fun."

When the high-gravity beers are allowed in his beer store rather than his liquor store, Nichols said that deciding what to carry will get tougher because the new options will take up valuable shelf space, but this could be a good thing. "When it comes over here, the offering is going to get bigger," Nichols said. "There will be more selection, wholesalers will pick up more lines, they'll come out with more SKUs and it's just easier to do more business. Right now, I can only buy high-gravity beer through a wine wholesaler."

The Casual Pint

The Casual Pint is a success story by all accounts. Initially starting with just one store, this "Starbucks of beer" shop was a retail business that let craft beer drinkers hang out, sample a rotating stocked selection, use the WiFi and generally enjoy themselves. As of 2016, the Casual Pint had nearly fifteen franchises sprinkled about the Southeast.

East Tennessee State University graduate Roger Flynn has developed the business's model into a well-oiled machine where his customers can grab a single out of the cooler; have a pint or a flight; or fill a growler.

"What we've done with Casual Pint is we've built a franchise model and we've been franchising stores around the country," Flynn said. "Casual Pint is a craft beer market that happens to have a bar in it with twenty-two rotating taps. The best way to describe it is, it's not a bar."

Many of the franchise owners are homebrewers who live and breathe beer, which is good because so many of their customers share that same passion. That love of craft beer is an opportunity for many homebrewers who may not have it in them to open their own brewery but might want to invest in a retail, beer-selling business.

As they sign up to have their own Casual Pint, Flynn's corporate team helps guide the shop, showing them how things work and what's been proven to be successful, all while not doing too much hand-holding.

"Corporate will assist them as they open up. As they get to know their market and their customer base, the owners will be the ones ordering the kegs and the beer that goes into their stores," Flynn said.

From there, it's very much at the discretion of the owner to operate his or her store the way he or she sees fit, with special events like beer releases for non-taproom breweries and food and drink offerings.

That is, of course, if the local municipalities will have them. Flynn and his team have had to work with small governments across the region, getting laws changed to allow businesses like Casual Pint to set up shop and operate. And so far, these efforts have been successful.

The Craft

There are many great and new craft bars in East Tennessee educating the public one drop at a time. Although it is not an exhaustive list, these three bars helped propel the East Tennessee craft scene to what it is today, the East Tennessee beer renaissance.

The Atlantic Ale House

The Lockmillers and Griebs of Johnson City opened the Atlantic Ale House in December 2014 with no expectations whatsoever. That's actually not entirely true; after fixing up an old bar into the craft beer hot spot it is today, they looked at the monthly bills and figured out that they would need to sell something like twelve pints a day to break even on the overhead bills.

Needless to say, they've been able to keep the lights on. The two couples, Jenny and David Lockmiller and Kelly and Jacob Grieb, put their heads together over porch beers one night and followed their idea through.

Their thought process centered on the idea that they—beer lovers—were traveling more than an hour over the North Carolina border into Asheville for beer all the time. Why not see what they could do about keeping beer on the East Tennessee side of the state line? And assuming there were others like them, they could open a bar with rotating local taps and keep both the area's growing number of brewers and their followers happy.

"I wasn't sure when we started that a place that served beer but not food would actually survive because we live in the Bible Belt and there's concerns that will people go to a place that only serves beer," Jenny Lockmiller said.

Staying true to their mission to only support small, local and regional breweries by putting their beers on their taps, the quartet of Atlantic Ale House owners actively recruit and seek out those deserving beer craftspeople. "We just really want to promote a local economy, and we do have some great local breweries," Jenny said. "We want to support others who are putting their heart and souls into what they are doing."

A Fermented History

The Atlantic Ale House's staff—including Ben and Lauren, pictured here—are always ready to make craft beer recommendations to their customers. *Courtesy of Tony Casey.*

Now with a small staff of two bartenders—Lauren and Ben, beer aficionados in their own right—they've grown the downtown Johnson City business beyond their wildest dreams in just a few short months.

They've not come away from their non-food-serving ways, but one big positive has been the inclusion of food trucks, which have turned out to make the perfect marriage for what the Atlantic Ale House has been pouring.

Through an active and popular set of social media platforms, updates are shared with followers as to what's expected in the coming evenings and weeks for the business. When a new food truck, contest, competition, civic event or performance will be there, social media is the best way to find out about all happenings.

Not particularly close to the Atlantic Ocean, the name comes from the Atlanta, Georgia company Atlantic Ice and Coal, which once operated out of that downtown location. The old bar is still in the building, and from there, with the handiwork of David Lockmiller readily available, the group spruced up the joint, including their Instagram-prized chalk board, which displays a numbered showing of their rotating taps.

What strikes Jenny most is the feeling she and her husband, along with their co-owners, get when they come by the bar and see that perfect mixture of people and energy, all fulfilling exactly what they were looking to do with the Atlantic Ale House.

"It's amazing how many people end up here together at the same time," Jenny Lockmiller said.

Suttree's High Gravity Tavern

Suttree's High Gravity Tavern is one of Knoxville's premier craft beer spots, having given its customers a barstool and place to order local and regional brews since 2012 and gaining popularity ever since. The key to Suttree's success has been the rotating taps, which go well with the ever-changing, gotta-try-what's-new characteristic of the average craft beer drinker. It's been said, "I'm going to be married to one person for the rest of my life. I'll be damned if I do the same thing with beer." If you'll follow that analogy a little further, Suttree's is the equivalent of a craft beer swingers' club.

Rotating taps at Suttree's equate to a fine reason for Knoxville's craft beer lovers to keep coming back, making this relationship with craft beer the opposite of monogamous, sharing the love with many liquid creations.

The *Knox Mercury*, an independent weekly news magazine that caters to Knoxville's diverse communities, even listed Suttree's as a runner-up in its "Top Knox Drink" contest under the category of "Top Beer Market/Taproom," with the famed Bearden Beer Market as the winner.

Being in elite Knoxville company is something Suttree's has grown accustomed to, being fresh on the lips of locals and tourists to Marble City who look for something fresh and different. Accolades have recently poured in from other media outlets, too, with the *Knox News-Sentinel* having quoted Ian Roach—the tavern's bartender and Knoxville native—about his work at Suttree's in early September 2015. "Suttree's is fantastic, and my favorite job by far," says Roach. "The owners are very nice and take great care of the staff. The staff has a lot of experience and runs smooth and quick. I've never dreaded going to work a shift there. And business is great."

Suttree's has moved smoothly through its early years, as is evident through reviews on beeradvocate.com, which links up beer lovers with the ability to grade and sound off, if necessary, against a given brewery or beer-related business. Jason Carpenter, who worked at Suttree's as one of the original beer consultants and bartenders, noted, "Suttree's is really important to the

Suttree's High Gravity Tavern celebrates the flavor and high gravity aspect of brewing. *Courtesy of Aaron Carson.*

craft beer scene because they aren't afraid to order beers you won't find anywhere else as well as a bar that specializes as beer first with both high gravity and low gravity beer." Although Jason has moved on from Suttree's, he still directs craft beer media at jasonknowsbeer.com.

9
THE TRI-CITIES CRAFT BEER AND CIDER RENAISSANCE

Winning Their Way into Bristol's Heart

Brewery: Bristol Brewery
Where: 41 Piedmont Avenue, Bristol, Virginia
What's on Tap: Piedmont Pilsner, Red Neck Amber, BFW Lager, Bearded Goat Bock, Double Loco Imperial IPA, Sunset IPA
First Pour: May 2015
The Story: True to a trend that's occurring across the country, Bristol, Virginia's Believe in Bristol literally and figuratively picked a winner in the Bristol Brewing Company when it decided on the victor of its "First Entrepreneurs" contest in 2014. According to the group's website, the goal is to better Bristol "by building a community of culture, lifestyle, heritage, music, and economy."

Bristol Brewery's owner, Ken Monyak, argues that a thriving brewery accomplishes most of the goals of the city of Bristol, Virginia. He said the contest they won, with their idea to put a brewery in the heart of historic downtown Bristol, really only required them to stay within a certain area to become a draw to all the good the city's center has to offer.

Recalling the judging, he said he knew they had a good shot because of the business they were proposing to bring into the city. "Downtown Bristol was really ripe for a brewery," Monyak said. "It fits what the Believe in Bristol people wanted, what both sides of the state line's city folks wanted in terms of a place for people to come and walk around and generally be a part of downtown. Just to add to the experience and not continue to be restaurant

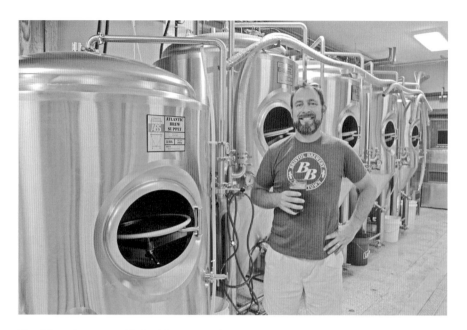

Ken Monyak, owner of Bristol Brewery in Bristol, Virginia, poses with the equipment that allows him to make his beers. *Courtesy of Aaron Carson.*

competition or an antique competition and just something that was eclectic that would add to people moving around downtown. I think that was the biggest part—that and we brought beer to the competition."

Monyak would like to believe that it was the content of his brewery proposal and the quality of his beer that won over the judges, and he'd certainly be correct. Like his regional peers, Monyak had been a homebrewer for years, dabbling in the fermenting arts with his neighbor to develop his style.

The money that he won in the contest was enough of a shot in the arm to pursue a brewery. Now faced with the challenges that present themselves when a homebrewer moves from a garage or basement multi-gallon system to the ten-barrel system the Bristol Brewery works with, the risks are greater, as is the pressure to put out a consistent product. While he hasn't produced long on a comparatively larger system, he's up to the challenges in store in the early stages of his business.

"My problem is going to be mechanically making things happen the first couple of batches, I'm sure," Monyak said. "Once I get that down, my recipes are pretty solid. As long as I can keep my ratios relatively the same, I think that the mechanical aspect of doing it on a larger system is going to be the challenge."

A Fermented History

No saturation level has been hit by Monyak and area homebrewers turned brewery owners, and he knows it's still a very chic business to be in. What a brewery offers the downtown blocks of Bristol is vast. Because of the requirements of the contest, the location was nearly set, but that was perfectly fine with Monyak.

"I think it's part of the downtown vibe," he said. "For us, our location is sort of predestined because in winning the competition, we were required to locate in the historic district of downtown Bristol. It was our dream, if we were going to do that, we wanted to be on State Street. We actually found a better location than State Street. We're just off State Street on Piedmont. That, to me, really is how we're going to be successful. People are going to move from State Street to Piedmont and around to Cumberland Park and that area."

Monyak and anyone else in his position who consider opening up a craft brewery that straddles the Tennessee-Virginia state line, which has significantly different state law options on either side, currently will make the choice to locate in the latter. The reasons are obvious, and though Tennessee legislators are scrambling to make the process as easy as possible for entrepreneurs like Monyak with craft beer on their minds, the incentives are still too great for picking Virginia.

For the Bristol Brewery, it was nearly the first thing on the owner's mind after he'd won the contest. "When we went through the process of winning the contest and said, 'We're really going to do this brewery thing. Where do we go and locate?'" Monyak recalls. "One thing that's essential is knowing the law. In Tennessee, the law is much different than it is in Virginia. We absolutely had the choice. We could be on the Tennessee or Virginia side, and we chose the Virginia side because the laws are so much easier."

Monyak cited, specifically, the alcohol-by-volume mandate of the state of Tennessee, which is 6.2 percent, significantly lower than what is allowed in the Commonwealth of Virginia, which has no capped amount. This allows Monyak to open up his imagination to produce as many high-gravity beers as he chooses.

Knowing that this is what many of his customers want, he'll be serving up craft beers of varying levels of alcohol. As a point of note, Monyak said of his lot of beers, only one would sneak under that 6.2 percent mark required in the state of Tennessee, though that figure is set to change on January 1, 2017. "We want to get a diverse beer set because what we're talking about is to have something for everybody," Monyak said. "There will be people who like a good dark stout, people who like an American light and those folks, the in-betweeners."

For the in-betweeners, Bristol Brewery wants to bring in new people to the market. Bud Light drinkers, he said, will simply stay home and drink their beer of choice or, if they do go out to drink, will only drink that single beer. Craft beer drinkers are not that way at all, and having options, much like Asheville, North Carolina, bodes well for the brewers seeking to be diverse in what they serve their customers and the setting that they'll provide.

The Bristol Brewery is housed in the old bus station in the downtown streets. This is good for the people who come in and want to experience that old-time Bristol feel, going back to the birth of country music that occurred during the city's famed 1927 Bristol Sessions.

For the Bristol Rhythm and Roots Reunion festival that takes place each year, Monyak's brewery has a special situation. Because so many artists are gracing stages throughout the historic downtown area, they all need places to warm up, which is what has Monyak hopeful that he can provide them a place to do their tuning—as well as provide something for his craft beer and music lovers to watch.

"Coincidentally, the main stage is at our front door," he said. "We're right there. Last year, we weren't open but we owned the building, but we were inviting artists into the building to warm up. We hope that our outdoor stage will be the warmup stage for the bands going forward."

The Core of the Craft

Cidery: Gypsy Circus Cider Company
Where: Kingsport, Tennessee 37660
What's on Tap: Raindancer, a Tennessee dry cider, and Queen of Swords, a Tennessee vintage cider
The Story: Aaron and Stephanie Carson noticed something was missing in the Tennessee craft beer and artisan alcohol boom of the past couple years. From Knoxville through the Tri-Cities, there were many breweries in the works, but none was serving cider. It was all very clear from that point forward, and they wanted to be one of the first in the state, and the first east of Nashville. They did just that in the second half of 2015 when they opened the doors to the Gypsy Circus Cider Company in Kingsport, which plays off a name given to the East Tennessee–based worldly folk.

Self-described serial travelers, the Carsons chose the name "gypsy" because that's what they've been called on more than one occasion, taking trips from Haiti to Cambodia to Bosnia. At times, they (lovingly) brought

their children along with them. Aaron says the name Gypsy Circus Cider Company is based on a philosophy of taking amazing elements of cider making from around the world, sprinkling in a few crazy ideas and making a Tennessee-style cider that has that bohemian flair. The results of these crazy ideas have been fun to sip and experience.

While Gypsy Circus will have two flagship ciders, you can expect the unexpected from this brand. The Raindancer is a semi-dry, fresh-pressed cider with champagne characteristics and a floral aroma. The result is a fruit-forward taste that is clean and refreshing, pairing perfectly with delicate dishes like chicken or fish or just an enjoyable session cider.

The Queen of Swords is a sweet, full-bodied cider with a rich apple aroma. The cider uses native and local apples to bring out fresh, ripe apple notes and has a nose of apple blossom honey and fresh-sliced apples. It is a clean and fresh cider with a light sweetness and a lively finish.

In addition to the flagships, these cider gypsies like to mix it up, too. The Elixir series includes fun and exciting ciders, such as the Fire Juggler, which is made with a three-pepper blend resulting in a slightly spicy cider with a semisweet emphasis and a fresh apple finish. Lastly is the Puppet-Master series, which are barrel-aged ciders that provide a long, rich finish.

Gypsy Circus Cider Company opened up in Kingsport as the first of its kind in Tennessee. *Courtesy of Matthieu Rodriguez.*

Tennessee whiskey barrels make the perfect vessel to create flavors with depth and character. "We thought it was important to show the amazing things that East Tennessee has to offer. By bringing together Tennessee whiskey barrels and Tennessee cider, you have a truly Tennessee product that represents the state."

"Our focus is on quality artisan cider made locally," Aaron Carson said. "We are big supporters of building and buying local. We believe in the orchard-to-glass movement, where each aspect of your craft and artisan product is sourced locally and sold locally."

Aaron Carson believes the cider industry, at least in East Tennessee, is no passing fad, and he's banking on it with his forty-barrel facility. As a family-owned cidery, Gypsy Circus aims to focus on these all-natural ingredients and locally grown apples. Tennessee is home for the couple; both of them spent their childhoods here, going to events like the Erwin Apple Festival. Looking back, Aaron Carson said he understood that apples were an important agricultural product in the region but never imagined he'd create a company that is projected to become a large consumer of those apples.

And the Carson apple tradition continues as this family business goes beyond Stephanie and Aaron, with their children, Elise and Aubrie, serving as quality-control testers on the apples and soft ciders that are served as apple juice at area events.

It's the apples they work with that make their final brews so tasty. "People understand that anything you eat or drink, to really understand what goes in the product. We don't take the shortcuts with the high fructose corn syrup or water it down. What you get with us is straight up local apple juice," Aaron shared.

The Carsons are, of course, a craft beer– and brewing-friendly family, which is why they've tackled such an endeavor. After home blending cider, Aaron Carson had refined his skills at the Cider Academy in the United Kingdom, setting in motion this business venture. Now stateside, they've been doing it domestically. "As members of the United States Association of Cider Makers, we understand that the cider movement is spreading and there is more of an appreciation for the various styles and unique attributes of artisan craft cider," Aaron Carson said. "Quality, consistency and excitement are the hallmarks we ensure is part of the cider we make."

Neighboring North Carolina has a handful of cideries—including West Asheville's Urban Orchard Cidery, which sets the standard for quality cider and helped provide inspiration for the Gypsy Circus cidery.

A Fermented History

The Carsons seek to be a part of this apple magic and will continue to be as adventurous as they are ambitious. Moving along into their second calendar year as Tennessee's first hard cider producer east of Nashville, they intend to be poured from tabs and drunk from cans, with all movements centered on the Core series of products, which are their flagship products.

That Sweet, Sweet Music

Brewery: Holston River Brewing Company
Where: 2623 Volunteer Parkway, Bristol, Tennessee 37620
What's on Tap: Magnificent Bastard IPA, Vanilla Creme Stout, 50 Shades Stout, Wooly Bugger Brown Ale, 423 Blonde Ale, SOHO ESB Ale, Scottish Ale, Farmhouse Ale
First Pour: May 2014
The Story: It was only half a decade ago that Holston River Brewing Company's previous owner, Jimmie Daughtery, picked up a mass-produced homebrewing kit to try his luck and recipes. Just like his love for cooking and the restaurant business—in which he'd spent many years—he wanted to put things together just the right way. A simple homebrewing kit soon wouldn't do, and he wanted to get down to the essence of what goes into a great craft beer. So he began visiting homebrew supply shops, and instead of using a can of extract and water, he dove in further, buying his own grains and a different, bigger system.

"This is a little too simple," he said on his transition from kits to actual beer systems.

Much like the beginnings of many other homebrewer turned brewery owner situations, it was Jimmie Daughtery's friends who'd come over to drink his beer who told him that he should open up a brewery.

Taking their prodding seriously, and knowing he had a knack for brewing magic, he got his parents to help him out in making that transition. He opened up the brewery with his wife, Sue. As smoothly as it went to decide to open, the logistics behind doing so were problematic to say the least.

Like other breweries starting up across the state, and certainly in the northeast portion of Tennessee, the Daughterys quickly realized that the governing bodies of the areas in which they planned to open up their business had incomplete statutes on the books in regard to the production of craft beer.

The Holston River Brewing Company opened up in mid-2014 and has since amassed a loyal following of fans. *Courtesy of Alison Hill.*

"Bristol, Tennessee, their beer ordinances didn't even address a brewery, so we first had to work with a city council and get them to change some of the laws and rewrite some of them," Jimmie Daughtery said. "That took about six months to get that done."

A seemingly endless pile of applications and paperwork, as well as zoning restrictions and location difficulties, added to the reason why the Daughterys were unable to open as seamlessly as they once hoped. This wasn't ideal for them, but Jimmie joked that it might help his future competitors who chose the area to open their breweries. "If someone else opens up in Bristol, we basically paved the way there for them," he said.

No doubt, it was his beer making that got the ball rolling in the beginning, but Daughtery hired a head brewer when he opened up in Bristol, Tennessee, and has since updated that position. Much like other newcomers to the craft beer business, or any business really, the Daughterys and their team have used the year-plus they've been open to work out kinks, operate exactly the way they choose and set the feel and tone for their indoor and outdoor spaces. "We've never been in the brewery business, just doing it at home, so we've learned a lot," Jimmie Daughtery said.

The Holston River Brewing Company is fortunate to have quite a bit of open room, which bodes well for the shows it has planned there. The campground is becoming prime real estate to see some of the best local,

regional and even national-caliber bands. "We do a lot of shows. Every weekend we've had someone, and a lot of good bands come through. We need some of them, so we're increasing our capacity…I had Alabama coming," Jimmie Daughtery said. "That fell through. But we have a three-tier level. It's like a big amphitheater. The promoter we were working with, when it was time to sign the contract and send the check didn't have the money to send the check."

Alabama or not, the Daughterys are ready to make runs at other large-scale bands to mix in with the passers-through and local shows. The Bristol Rhythm and Roots Reunion and the newly opened Birthplace of Country Music Museum, which happens to be just over the Tennessee-Virginia state line, draw in more than fifty thousand people to enjoy one of the region's best products: Appalachian-style music. Many would argue that nothing goes better with listening to old-time music than a cold glass of something with alcohol in it that was produced locally.

Music isn't the only draw for the Holston River Brewing Company. Because of Jimmie Daughtery's history with food and the plethora of dining options in the Tri-Cities, there's also been a food and craft brew connection. Having worked at the Tavern restaurant in Abingdon, Virginia, where Jimmie said great food is produced, he's playing off the idea of wine and food pairings with a series of craft beer and food pairings, which are becoming more popular with seemingly every new brewery that pops up.

"I focus on the beer, but I think it's good to work with a local restaurant," Jimmie said. "When you think of pairing, in the past, it's always been wine. Wine goes with this and wine goes with that. I think it's kind of fun. In this area, it's new for people to go to a beer dinner pairing."

As far as the beer that the Holston River Brewing Company actually serves, the company has endeavored to start off with about four beers—the 423 Blonde Ale, SOHO ESB Ale, Osceola Island IPA and the Vanilla Creme Stout—and after those, it will have its specialty playground, where the fun can occur. Often, that fun is turning a traditional beer drinker on to the world of craft beer through the productions of the Daughterys' brewery.

Jimmie Daughtery has the perfect transition beer for those people, a challenge he whole-heartedly takes up. "It's our 423 Blonde," he said. "It's a real light beer, but it's that transition. Someone comes in and that's the beer I'm going to steer them to. If they say, 'I've only had Bud Light,' that's what I'm going to steer them to."

Jimmie sold off his share of Holston River in early 2016, enabling the new ownership a chance to build on the brand he helped create.

Life Is Short

Brewery: JRH Brewing Company
Where: 458 West Walnut Street, Johnson City, Tennessee 37604
What's on Tap: Boone Time Blonde Ale, Boone Time Strawberry Blonde, Fat's Tired White IPA, Portly Porter, Vanilla Rum Porter
First Pour: January 2016
The Story: Jill and John Henritze shared the same career leading up to the opening of JRH Brewing, with both working as physician's assistants. While Jill continues to work in this line of healthcare, John has since moved to getting the family brewery up and running full time, converting a West Walnut Street building from a tire store to what will be a taproom and brewhouse that emphasizes a strong list of tried-and-true brews, as well as an innovative place for local beer lovers to think, ponder and enjoy the time-old tradition of drinking handcrafted beer.

Getting up and running was somewhat of a challenge for the couple, but they had an overall positive experience working with the State of Tennessee to pursue this dream of theirs. And positivity is kind of their thing.

After an unfortunate set of personal circumstances hit them hard—Jill was diagnosed with ovarian cancer, a friend suffered the same diagnosis and another friend suffered a stroke following a brain aneurysm—the Henritzes came to the conclusion that time is short and it should be spent pursuing dreams, doing the things one is passionate about and listening to the experiences of others. All those things combined have molded and shaped JRH's business.

For starters, John is taking advantage of a huge back wall in his building that will be called the Dawn Wall, from which inspiration is expected to explode. Customers with a clever thought, bright idea, dream or vision can take to the wall and share their plan. Of course, the owners argue, these ideas will only get better with their beer.

"Our tagline is, dedication, determination and delicious beer, and that's kept me going," John said. "It's those things that drive us."

This clarifying process John and Jill went through helped them hone their own focus on how they envision the rest of their lives going, being happier and sharing that happiness with others, be it through beer or the spoken word. A big part of this life-changing process was John's realization that he was going down the wrong path. Not in the all-too-common sense that he was addicted to drugs, alcohol or some other dangerous lifestyle, but he simply wasn't happy with what he was doing. He worked a job because he

A Fermented History

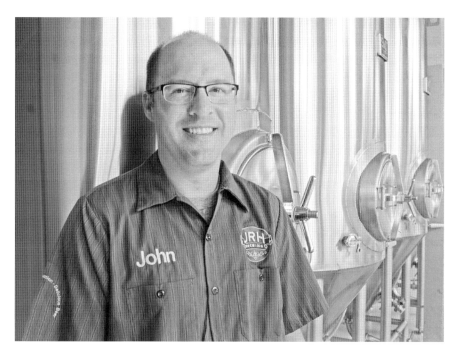

John Henritze co-owns JRH Brewing in Johnson City with his wife, Jill. *Courtesy of Nathan Baker and the* Johnson City Press.

needed to work the job; and it was a great job at that, but he wasn't as happy as he could be.

Combine this feeling with the passion he's had for making beer, and it was rather clear that he would make that move into brewing full time. He explained the way he felt before pursuing beer:

> *I thought it would be awesome to make beer for a living and be the guy on the other side of the glass. It just so happens, everybody says, "You have to go to college." I kind of thought, "Yeah, I have to go to college," and I picked a career and picked courses. I ended up going down the path of sports medicine, got a glorified PE degree. Then, I got interested in sports medicine and physical therapy. I ended up where I am now.*

But that never stopped his brain from thinking what could have been. He continued:

> *I graduated in 1992 from high school. It's* [craft beer] *not as big as it is now then in the late eighties, that's when it was kind of coming up as*

a craft. Dogfish Head is twenty or so years old. 1993 is when it started. Right about that time is when I wanted to do it, but it wasn't anything anyone was saying I could do. Take a time machine—if I could pick and choose my things, then absolutely I'd do it different. I'd be doing the same thing as the rest of the guys who'd succeeded and done well with it.

John's first batch of beer was produced when he was in college in 1998, but his first thoughts of becoming a brewer came about in high school when he might not have been operating completely inside the confines of the law—he was just a young buck then.

Crafting beer through the end of high school and his time at George Mason University, Henritze was never too far away from his passion but far enough away, occupationally, to have those thoughts in the back of his mind that he might be happier applying his patience to beer making rather than dealing with medical patients.

"I've thought long and hard about doing this for another twenty-five years," he said. "I don't know if I want to do medicine. I know I don't for another twenty-five years."

Having learned in beer school that it was sort of a "go big enough when you start" kind of situation, the JRH Brewing Company will be supplied with and fueled by a ten-barrel system from SMT Brewery Solutions and Machines out of Virginia.

The Craft Beer Renaissance

Brewery: Johnson City Brewing Company
Where: 300 East Main Street, Suite 104, Johnson City, Tennessee 37601
What's on Tap: Little Chicago Stout, Perfect Tenn Blonde Ale, Downtown English Brown Ale, Sweet Pale Ale, Southside IPA, Kick of Coriander
First Pour: October 2014
The Story: Eric and Kat Latham started Johnson City Brewing Company each with nearly a decade of homebrewing experience under their belts. Having started the Peyton Street Beer Club in Winchester, Virginia, the duo sought to bring together family and friends with a similar love for brewables. The goal was to explore a collective love of beer, but Eric said he loves the way it can bring people together, which he's seen time and time again in his travels.

A Fermented History

Eric Latham's travels have included two trips across the country—including once on foot—where he looked to have conversations with people on the topics that affect the United States the most, like cancer.

"There kind of is a renaissance that's happening in this country," Eric said. "Due, in part, because breweries are popping up. They're bringing along art, music and wonderful food, community and economic development."

For the Lathams' business, which can be found tucked into the corner of the bottom floor of the King Centre in downtown Johnson City, there is much community taking place. They offer a membership to their loyal followers, who have their own numbered mugs hanging in their taproom, always waiting to be filled and refilled. The people who come back for more of the Johnson City Brewing Company's year-round craft beers and seasonal and limited edition varieties are certainly beer lovers, but the owners believe they're frequently returning to support something else.

"It's a pretty small operation, but we've learned that the people coming in here are interested in our company and craft beer, but I think many of them are interested in the revitalization of downtown Johnson City," Eric said.

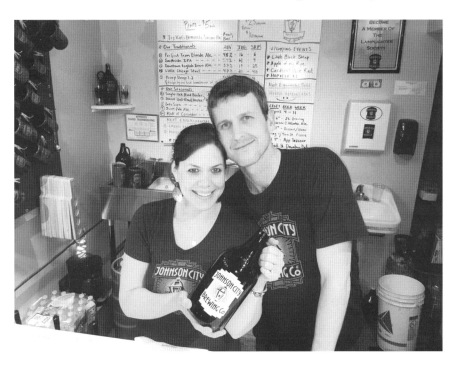

Kat and Eric Latham are part of a conglomerate of craft beer–loving friends who put their heads and funds together to open the Johnson City Brewing Company in late 2014. *Courtesy of Kat and Eric Latham.*

"I think it speaks to the Tri-Cities. It's not just Johnson City. It takes certain individuals for a place like this to work, any business to work, really."

They've also worked on a Blue Plum beer to celebrate downtown Johnson City's biggest free festival. This idea came about like many others do for the Johnson City Brewing Company: by the selection of their fans. When the Lathams put out an experimental batch in a flight, the Blue Plum brew rose to the top as the clear favorite. That was a good enough reason for Eric to make more for the festival.

"They get to vote on the one they liked the best, and that's the one we're going to make," he said. "We're actually using blue plums. We're going to get the puree from that and put it on the blonde base and make it for the festival."

It's in these special batches and selected brews that Eric and Kat Latham have the most fun. Their Thai Toasted Coconut Porter is the same way. They used beans from a local coffee producer, loved their results and will continue to produce the darker craft beer, with a special Thai-focused event planned to both educate and entice lovers of culture and craft beer.

Events like this are part of the art and communities that are saddled with breweries in America and only benefit the region where they take place. This communal atmosphere isn't just driving local craft beer markets today; Latham argues that it's been around since the dawn of the United States.

With great interest in American history, Latham remembers reading about the country's second president—John Adams—allegedly started each and every day: with a stiff cider. Latham sees it as a way that modern craft beer lovers and move-makers can fuel their decision-making processes à la the forefathers. "They'd get together at some of these pubs, some in Philadelphia, where they got together in the late 1700s to discuss the future of this nation," Latham said.

He said it's a dream of his to see big ideas begin in the same fashion, in towns and cities across America. Calling the place where their new customers, old customers, family and friends converse "their living room," they've found a special spot to meet. "For one year in business, that's a pretty good thing," Eric Latham said. "We call this our living room. We're pretty humble pie."

As one of an ever-evolving list of breweries to hit the Johnson City area, the Johnson City Brewing Company boasts its ability to make some standalone classic brews well and then roll with the punches, seasons and flavors of the wind that blows past it to produce special beers that will keep their lot coming back for more.

A Fermented History

There are more than 125 beer mugs placed on pegs in the taproom for the brewery's members, those who've paid to be a part of their social drinking club, much like how it started on Peyton Street in Manchester, Virginia, years before. Though they're on a different street this time around, the rules are nearly nil, but the customs still remain the same: be a part of the craft beer, be comfortable and be a part of the conversation.

For the Lathams, their goals for the beer they produce are the same as they've always been. "You want to make the best possible beer you can," Eric Latham said. "The other part is that you work very hard to make something and you're here until two or three in the morning and you have to sleep here and you're sleeping on a futon mattress in the back room and don't go home to visit your wife and kids and you work your ass off until 3:00 a.m. or 4:00 a.m. and you drive home or you decide to stay here and start your day job in the morning."

With the help of his friends, loved ones and financial backers, Latham did take that step to turning his love into a business, and he, with Kat right next to him, can't wait to see where it goes next.

The Banjo and the Brewer

Brewery: Sleepy Owl Brewery
Where: 400 Clinchfield Street, Suite 100, Kingsport, Tennessee 37660
What's on Tap: Heritage Honey Ale, Sodank IPA, Hickory Tree Brown Ale
First Pour: April 2014
The Story: For years, Brian Connaster, a homebrewer himself, would reward himself for his relentless work as a software engineer by frequenting Asheville-area breweries, drawing inspiration for what was one of those big ideas that hit you like an apple falling on your head, which was opening a brewery. He'd bring his wife and children, who he teaches at home, and mix in two of the region's best offerings—specially crafted brews and mountain views. After a long day of hiking in either the Pisgah National Forest or the Dupont State Forest, the Connaster family greatly enjoyed settling into a welcoming brewery, where the presence of family fun was common.

Working with computers was something he'd done for almost two decades, logging eighty-hour weeks built on sixteen-hour days in the later stages when he was opening up his brewery. He was always saving and investing in his plan and idea but, at the time, wasn't sure the brewery would be in Kingsport, Tennessee.

Considering a move to Brevard, North Carolina, to explore becoming a full-time brewer, Connaster's family was lining up their options for the future. Because he could work as a software engineer remotely, he could do both for the time being.

It was at the 2013 Thirsty Orange Brew Extravaganza in Johnson City that the homebrewer's craft beer talents were recognized. Connaster's cousin tried one of his beers and said very much what a cousin would say—"that it was delicious." But soon word spread to the right ears, and his beer fell on the right taste buds. Connaster's phone rang with an opportunity. Miles Burdine, the president and CEO of the Kingsport Chamber of Commerce, called Connaster to offer the chamber's help.

"We were driving back on a trip to Nashville one night and Miles calls me and says, 'Hey, I heard you want to start a brewery and are moving to North Carolina to do it. Why don't you talk to us first? We'd love to have a brewery in Kingsport.'"

A few months down the road and a few more connections made, some of the area's notable movers and shakers were down in Connaster's basement—his man cave—sampling his creations with great interest. The consensus was clear. They liked what the homebrewer was doing and collectively told Connaster, "Let us know what we can do to help you." Two months later, Connaster rented the space in which Sleepy Owl Brewery can be found today—in suite number 100 at 400 Clinchfield Street in Kingsport.

As smoothly as things were going leading up to the time Connaster rented his space, he was then about to be hit with a shocker. "You're one of sixteen that's getting let go immediately," he was told by his employer. "Sales aren't that great."

The news hit the aspiring brewmaster like a ton of bricks. All the income fueling his plan was cut off. Not a man who's used to giving up, Connaster used his computer skills to start a Kickstarter campaign in which he asked his fellow beer lovers and supporters of small business to kick in a few bucks each to make his dream come true and help Kingsport land this brewery, which would be a crucial element of the downtown scene.

The results were quite impressive. His thirty-day Kickstarter earned more than $26,000 from 198 different donors who all bought into the idea. At its grand opening, Sleepy Owl Brewery's craft beer impressed more than cousins and Kingsport-area businessfolk. "We did not expect the success that we had," Connaster said. "We ran out of beer in two hours. It was a little crazy."

Now, more than a year later, Connaster said he's simply trying to keep his head above water, producing as much beer as he can. It's a good problem to

have, in that everyone wants what he's making, but he's stressing his smaller system's capacity.

It was on those what could be loosely called "family research trips to Asheville-area breweries" that Connaster would find the atmosphere that he was looking to emulate with Sleepy Owl Brewery. The Wedge, Connaster said, was the most inspiring of them all. Located near the French Broad River in the River Arts District, the Wedge prides itself on the slogan, "Beer Is Art." For the proprietors of this brewery, that means providing for the people of Asheville and its many beer-loving visitors "a throwback to the neighborhood brewery." More locally, Connaster gives credit to the way Abingdon, Virginia's Wolf Hills Brewing Company developed the local scene for breweries to also showcase music.

Along with its standout beer list, Wolf Hills is also able to provide the means to both feed and entertain its guests with the inclusion of area food trucks and by showing films outside.

Connaster does something of the same. Since its opening, Sleepy Owl Brewery, like other area breweries, has been able to thrive with the same offerings. Vendors like the Noli Truck and Fire in the Hole's portable wood-fire pizza ovens have been keeping bellies full. Performances by several bands each month give the brewery's frequenters even more of a reason to keep coming back.

Sleepy Owl, brewing with local grain. *Courtesy of Tony Casey.*

The owner said he's somewhat surprised at how quickly his brewery has grown into both a Kingsport hot spot and a regional music venue. If one of the downtown restaurants has a band playing, Connaster will have his bands playing just after, hoping that these music lovers will make their merry way to Sleepy Owl Brewery from the downtown area.

It doesn't matter if they're coming to his establishment for his beer or for the music; the way he looks at it, at least they're coming. "We've become known as a really good listening room," he said. "The acoustics are good in here. We have a really nice PA system. We always planned to have music, but we've turned into a small music venue."

Bourbon and Tequila Barrels of Fun at Studio Brew

Brewery: Studio Brew
Where: 221 Moore Street, Bristol, Virginia 24201
What's on Tap: Galactic Elf, Southern English Brown, Belgian Table Beer, Litchi Farmhouse Ale, the Acoustic Sunset, Chocolate Porter, White Oak Bourbon Barrel Aged Belgian Triple
First Pour: November 2015
The Story: It's a truism across the world of craft beer, but you'd be hard pressed to find anyone who has more fun tinkering and honing his trade than Studio Brew's founder, Erich Allen. The Sullivan County man and his wife, Pamela, aren't the pair to be boxed in by settling on one style or one process of beer making. Whether it is bringing out the flavors of bourbon or tequila barrels to mix with his beer, brewmaster Erich gets the most out of his ideas and the resources he uses to make his batches of suds.

"Our twist is that we're just so big and bold and out of the pocket," Erich said about Studio Brew's process, something he's developed over time. Not arrogantly, he explains exactly how he uses what he considers to be his best brewing and creative characteristics to get to his end product. "I've been very gifted in my life. I'm not very book smart, and I really have a hard time reading. But I can look at something and just realize the end result. That's the whole thing. That's visualization of the finished results."

This kind of modesty is typical with Erich, but his march to opening Studio Brew came through the trial and error of another line of work, though his

only error might have been timing, having a business that would be affected by downturned markets and a tanking housing industry.

His work with commercial and residential audio, video and smart technology did the same thing as many others involved with the industry, giving him more time on his hands than he was used to.

Eureka! he thought, he'd make some beer. Starting with kit beer, as many do, Erich quickly decided he liked to pursue endeavors with more fervor and jumped directly into brewing with everything he had, making friends and catching ideas from his pals at the State of Franklin Homebrewers Club, who had met at Depot Street and really inspired him to be the best he could.

Remembering the experience as something that could only be described as philosophy changing, Erich was a new man. He said of the meeting:

> *We met all these incredible people, in different age groups and different social dynamics. It didn't matter. It was all about the love of beer. There was that common ground through the whole thing. I ended up coming home after a couple hours, around 10:30, and my wife says, "How was it?" I went, "Pam, it was like a religious experience." The smell, the aromas, the people were introducing me to incredible craft beers, but also to understand my palate. They were introducing me to my palate. Do you smell this, do you taste that? I've got one good brain cell, and it exploded.*

It was hard for him not to go all-in after that. And that was the ignition switch that pushed Erich into the business. He recalls the respect he had for his peers and his philosophy that he didn't have to reinvent the wheel, he just had to add his own twist to what he knew would work.

Over these past few years, Studio Brew has been a staple of the local beer scene, working its magic at nearly each and every regional craft beer festival and operating out of its own space, which became the Tri-Cities' third craft brewery, behind Depot Street and the Sophisticated Otter.

"I'm so anal on being 100 percent that we don't use barrels more than once," he said. "I use a barrel one time, then we sell them. They're not cheap. They're $200 to $300. They're about $100 to ship. That's why we sell our beer a little bit more expensive than others. The reason we do that is because of the demand from our customers."

A hungry go-getter, Erich finds himself in the midst of opening up his second location, this one in Bristol, Virginia, where state regulations are more favorable to a brewmaster than they are in the state of Tennessee.

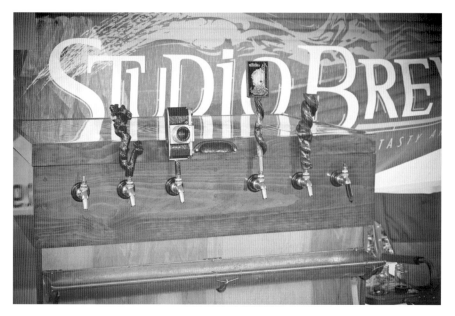

Erich Allen's Washington County, Virginia–based Studio Brew has produced some of the area's most adventurous and popular suds. *Courtesy of Pam Allen.*

According to the *Bristol Herald Courier*'s Kevin Castle, in a June 28, 2014 story, the Allens' renovation of a tobacco warehouse at 221 Moore Street will cost a cool few million dollars, and they will get the location up and running with the help of a few grants. Castle discussed some of the building's history and what Erich will do with the building:

> *The 20,000-square-foot structure is listed on the National Register of Historic Places and once had a skating rink on its upper floor. It's been standing mostly vacant and in disrepair for decades and in recent years had been targeted as the site for a fire museum while organizers looked for financial backers but that did not happen.*

The Allens will have fifteen- and thirty-barrel fermenters in their second Tri-Cities brewery.

A Fermented History

Yee-Haw! There's a New Sheriff in Johnson City

Brewery: Yee-Haw Brewing Company
Where: 126 Buffalo Street, Johnson City, Tennessee 37604
What's on Tap: Octoberfest, Dunkel, Eighty, Pale Ale, IPA, Pilsner
First Pour: July 2015
The Story: In the summer of 2015, the game changed for Tri-Cities beer when Yee-Haw Brewing opened up in Johnson City's downtown. Mixing the storied architecture of an old train depot with the modern craft beer movement sweeping through the region, Joe Baker's company solidified the strength of a local movement and the blossoming economy of a downtown that hadn't boomed in decades. Baker sees himself as a beer lover, but the Gatlinburg native, who now lays his head in Johnson City, also wanted to invest in his community.

Having developed a historic train depot on the south side corner of State of Franklin Road and Buffalo Street into a building that contains the Tupelo Honey Café, Baker was one day struck while enjoying a bite to eat. "That's how it happened," he said. "As I stood over at Tupelo and had lunch, and facing this depot, we needed to do something with it." So

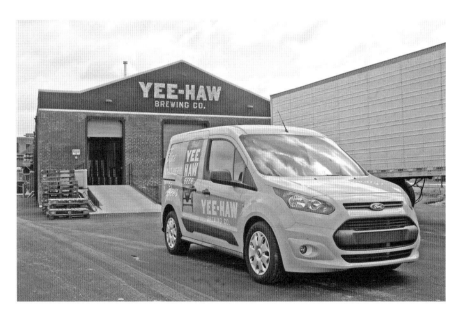

When Yee-Haw Brewing Company opened its doors in downtown Johnson City in mid-2015, it became one of the biggest craft beer players in the state. *Courtesy of Tony Casey and the* Johnson City Press.

he and his team took it from the former tire warehouse, with its unique architecture, to the shiny success story it is today. Baker knew he wanted to put a brewery in the spot.

"I like beer," he said. "That's why we got into the business, with a passion for beer. We're in a fortunate position where we're able to make our own beer, and I was excited to invest in and be a part of that industry."

That same passion isn't found in everyone, and his immediate goal was to find someone whose fire matched up well with his. He admits he wouldn't have welcomed just anyone in to be his head brewer. He was looking for the right guy to introduce and develop a brewery around, starting first with a clean pilsner, the first beer he sought to produce and produce correctly.

He wanted someone who could not only make the beer he was envisioning but who also could scale up production as the brand and popularity grew. Brandon Greenwood was the right man for the job, having built a fine résumé by brewing for Mike's Hard Lemonade and Lagunitas. In Greenwood, Baker found the man he was looking for; all he had to do was supplant him from where he resided in Chicago. "He's got a young family much like I do, and we seem to be focused on the same types of beer for what we wanted to make," Baker said. "It was a natural fit."

In the months that Yee-Haw has been open, with its pilsner, it's put out six beers in total, with more seasonals in the works. Greenwood's overseen the creation of an Octoberfest, a dunkel, an Eighty Scottish ale, a pale ale, an IPA and the pilsner.

Their back-and-forth communication is productive and open, but as much as Yee-Haw started with Baker's vision, he trusts his brewmaster to do his thing. "We talk every day, but I'm certainly not a micromanager," Baker said. "We're in this to have fun and grow a business. So he has strengths that I don't, and I appreciate that and I try to foster his knowledge and expertise and give him a lot of latitude."

In assembling a team of brewers, logistical experts and events and marketing folks, Baker has achieved that goal of being a part of the community. Jeremy Walker, listed as Yee-Haw's director of mayhem, has seen to it that the brewery is integrally embedded in the Tri-Cities area, which has begun thriving on activity.

An off-road cyclist himself, Walker has collaborated with the nearby Trek Store to help put on a Tuesday Trek bike ride around the neighborhood that includes an after-ride Yee-Haw beer and tacos from Holy Taco Cantina, just a few blocks down from Yee-Haw's in-house taco shop—White Duck Taco, which is popular across the state of North Carolina.

Yee-Haw also provides a free mini-glass of liquid fuel to local runners on a weekly fun run that ends up at another nearby Yee-Haw beer–serving establishment.

Baker thrives on that and says the most gratifying part about his job is getting thanks from his customers, who recognize that being a part of a community is as important as making money through selling craft beer. "If we're not a part of the community, then we're nothing," he said. "When we decided everything from what we would sell here to our hours of operation, I want families to feel comfortable coming and hanging out. I want to make this something that was fun for everybody, whether you're a family or a couple of guys in their thirties wanting to have a beer. For me, supporting healthy lifestyle activities like biking or running—to me, that's more community building. I'm big on taking my kids to do those things. I ride bikes all the time, and I think anything that promotes wellness and families and community is ultimately good for us."

I Think Wolf Hills Has Got It

Brewery: Wolf Hills Brewing Company
Where: 350 Park Street SE, Abingdon, Virginia 24210
What's on Tap: Troopers Alley IPA, White Blaze Honey Cream Ale, Creeper Trail Amber Ale, Fightin' Parson's Pale Ale, Wolf Den Double IPA, Stonewall Heights Stout, Black's Fort Brown Pale Ale
First Pour: August 2009
The Story: While Wolf Hills is just outside East Tennessee, it has played a pivotal role in the craft beer culture of the area. Like most breweries, both the beers and the brewers change, and Wolf Hills is no exception, introducing Todd Walton and Gabe Hinkley as the new brewers in 2015. Former brewer Drake Scott played a pivotal role in Wolf Hills' place in East Tennessee brewing.

Persistence certainly paid off for Drake Scott to acquire the top brewer's spot at Wolf Hills Brewing Company. As a young brewer of many beverages, Scott left college at the University of Georgia looking for his big gig at a brewery. His résumé included a lot of beer-related activities: he had worked at a homebrew shop and volunteered his hours and efforts at the Terrapin Beer Company. Studying economics at the time wasn't the first and foremost thing on Scott's mind, and he had worked at a brewery in England over the previous summer.

A frequenter of probrewer.com, he kept his eyes on the classified job listings to see what might be available to a person with his particular set of skills. This all took place in 2008, when Scott saw a post made by Wolf Hills, which prompted him to send over his professional materials. That opened up the line of communications, tempting Scott to do something a bit out of the ordinary, which is a trait many people have come to expect from him.

"I just drove up and didn't tell them I was coming up," Scott said. "It was about a five-hour drive from where I lived in Georgia."

Unfortunately for Scott, Wolf Hills was only open on Tuesdays and Thursdays at the time. It being a Thursday, he was greeted with a sign saying the brewer was sick and he would see customers again on Tuesday.

"So, I was like, 'Shit, I've got to find these guys,'" he said. "I ended up going to the coffee shop, which was still there, Zazzy'z."

Being a small town, someone at the coffee shop had some numbers that would help Scott in his quest to find the proprietors of Wolf Hills. Making the proper connections, Scott met up with the management and learned they were looking to fill the head brewer position. As much as they liked Scott, he said they weren't ready to see him drop out of college to brew for them, and he headed back to Georgia.

Following graduation, it was off to a job with Stone Brewing Company in San Diego, California, where Scott would work for more than a year, gaining more experience all the way. That's when the post came up again on probrewer.com, and Scott's imagination again drew him to southwest Virginia, where he felt he could be his creative self and apply his economics degree to the daily business he'd do at Wolf Hills.

After flying across the country to meet with the owners again, Scott started in June 2012, which was a good time because Virginia had just changed its laws to allow for the filling of growlers and free tastings.

"It was just even more opportunity to use the tasting room as a good avenue to make some money and have a good community hub and do some fun, entertaining things there and build off that for the distribution side," Scott said. "Then we could put all the money back into it from the revenue generated from the tasting room and buy equipment."

Scott thinks his time in San Diego was immensely valuable because he was able to learn how to maximize processes to be able to do more in the time they had. When Scott jumped on board, he brought with him the know-how and means to win awards with the beer he brews on Wolf Hills' seven-barrel system. His business plan was to layer in more fermenters as he went, staying true to the original intent and model of the company.

"Right now, the plan is to just keep adding fermenters as the demand increases," Scott said. "Maybe someday down the line, we'll jump into a larger line, but for now we're just trying to keep growing organically and not get too far out of line with where the company started with a thirty-one-gallon system."

Music is almost as big of a part of what Wolf Hills does as beer, having become a regional music venue. Now Wolf Hills' phone rings constantly with offers from bands to play their spot.

The brewery's position in Virginia also lends itself well to Scott's business senses, allowing for the sale of those high-gravity beers, compared with the current restrictions in the state just below its border.

That doesn't mean it's 6.2 percent alcohol and higher stuff that's most prominently coming out of Wolf Hills' taps. The Troopers Alley IPA is 5.9 percent and is one of the brewery's most popular selections, especially coming out of the can. Being so close to the Volunteer State has it catering to the lower alcohol drinkers, boding well for distribution and sales.

This all changes on January 1, 2017, when more high-gravity beers will be allowed in Tennessee, but having been around the block a few times, Scott gives the nod to the more progressive states in regard to beer laws.

"There are definitely areas around the U.S. that are more ahead of the curve," Scott said, citing more regional examples. "Asheville is ahead, and out west they're just light years ahead of everybody as far as consumers' knowledge on beer in general. We can work together on a group and make sure that people are more aware of craft beer and what it is—the different flavors and attributes in a beer, what brewing equipment looks like and how cool it is to have a brewery within a few minutes of your house that has the freshest beer around."

Scott takes pride in the work he did at Wolf Hills, making the freshest beer he could, all the time rocking his famed brightly colored clothing that 1990s-era World Wrestling Entertainment athletes would appreciate. Wolf Hills entered 2016 without Drake Scott or Josh Gambrel, their former brewers, but is heading in another exciting direction with its new team.

10
THE KNOXVILLE CRAFT BEER RENAISSANCE

An Alliance of Active Culture

Brewery: Alliance Brewing Company
Where: 1130 Sevier Avenue, Knoxville, Tennessee 37920
First Pour: October 2015
The Story: In forming their brewery, Adam Ingle, Chris Morton, Ben Seamons and their collection of company officials have formed a special bond—or alliance, if you will. They've named their business the Alliance Brewing Company, which aims to make an active and social community as much as it does craft beer.

Ingle is one of those leading the charge for Alliance. During the process of opening up the first time, the Alliance founders hit a setback when the landowner they were purchasing from yanked the opportunity out from under them, leaving their plans to work in the twelve-thousand-square-foot building with a thirty-barrel brewhouse meaningless. After a reset and replanning stage, which had them go through nearly a dozen other buildings, they settled on their current location, which is smaller but has all the features they were seeking.

"I would say we were extremely picky," Ingle said.

Morton, owner of the Knoxville-famed Bearden Beer Market—the place from which he poached the original employees to create this endeavor—could flip back the pages of the calendar to 2010 when the plan was formed while shooting the breeze and selling beer in the store.

A Fermented History

Stemming out of the employees of the Bearden Beer Market came the Alliance Brewing Company in 2015. *Courtesy of Adam Ingle.*

"We basically lined up Alliance Brewing Company in February of 2010," Morton said. "And this has been the process and, yeah, it's a dream job. But it's not a dream. It's a career."

Because Bearden Beer Market was such an instant success, growing in popularity and what it offered almost exponentially, Ingle, with his background in homebrewing and his assistant brewer, who was the market's "employee no. 3" behind Morton and Ingle, brought it all together. "So, employees one, two and three have been together since then, April of 2010," Ingle said. "The idea's been kicking around and we've been homebrewing since around then."

Has it taken some time? Yes. But is there a silver lining to a long opening process? Yes. Ingle has more than 150 test batches under his belt, brewing as little as five gallons and as much as fifty gallons and crossing more than forty styles of beer.

Alliance has plans for a German-style Kolsch, an oatmeal stout, a Belgo IPA, a smoked Scottish ale, a session IPA, a rye saison and, when allowed legally, some high-gravity beers. The brewery will have its core six beers on tap all year long and then another four to six taps for guest pours, maybe with some gluten-free options and room to have fun with seasonals.

Knoxville is ready for Alliance and all the breweries that are opening up, Ingle believes, referencing that void he and the other original employees experienced years before.

So the opportunity is finally here for the new brewing company to serve the Greater Knoxville area and its ever-increasing number of tourists and beer lovers exactly what they need: a cold craft beer made by a handful of people who really know their stuff.

If Ingle and Morton, two athletes, have it their way, Alliance will be surrounded by a social group of active people, eagerly willing to participate

in group bicycle rides and runs, all either starting, finishing or starting and finishing from the brewery, where participants can replenish their lost calories with a cold pint. Morton has more of an endurance sport background than Ingle does as a cyclist and runner, but Ingle's rugby experience could also draw in a different kind of athletic crowd.

There are many options for trails for the runners and off-road cyclists; open, paved roads for the speedy bikers; and open water for kayakers and standup paddleboarders, all of whom could combat their sweat with some Alliance beer.

But not too much, as has been recommended by the company's management. "We're trying to stay as active as we can, trying not to get too fat," Ingle said. "Drinking too much beer is the problem. Drinking craft beer all the time, you have to counteract it."

Morton remembers that well from the early Bearden Beer Market days, when he would take advantage of lulls in the day to throw a "back in 15 minutes sign" on the door and snag a few miles' run. If he returned and the lull was still there, he'd pop the sign back on the door and do it again.

"Even after we'd opened, I was running here just for fitness so I could drink more beer while I was working," he said. It was a brilliant scheme.

Adam Ingle, *second from the right*, is one of the main men at Alliance Brewing Company. *Courtesy of Adam Ingle.*

Michael Foster pouring a perfect pint from Depot Street. *Courtesy of the* Johnson City Press.

Casual Pint's founder Nathan Robinette showing an incredible selection of craft bottles and beers. *Courtesy of Nathan Robinette.*

Above: Sleepy Owl Brewery owner Brian Connaster doing what he does best. *Courtesy of Tony Casey.*

Right: Enjoying the festivities at Tennessee's largest Oktoberfest, the Tennessee Oktoberfest. *Courtesy of Robert King.*

A delicious elixir from Knoxville's Brewhibition. *Courtesy of Alison Hill.*

Left: Limited edition World's Fair beer cans from 1982. *Courtesy of the* Knoxville News-Sentinel.

Below: Brant Bullock looks on next to a trestle line's worth of hops at the King Family Farm in Piney Flats, Tennessee. *Courtesy of Tony Casey.*

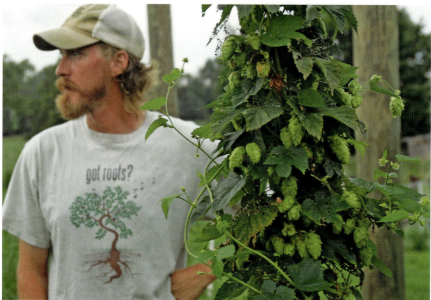

Ron Downer, one of East Tennessee's original brewers, enjoying a frosty beverage. *Courtesy of Ron Downer.*

BJCP judge and competition director Matt Raby presenting an award to Wes Jones for the Black Forrest Brew Off. *Courtesy of Robert King.*

Left: Amanda Stansbury representing Midnight Oil homebrewing at a festival. *Courtesy of Robert King.*

Below: Adam Palmer and Saw Works, a stalwart of the Knoxville brewing community. *Courtesy of Aaron Carson.*

The full complement of artisan-made beer glasses for every occasion from the Pretentious Beer Glass Company. *Courtesy of Matthew Cummings Studio.*

Stephanie, Elise and Aubrie Carson inspecting the orchards for Gypsy Circus Cider Company's apples. *Courtesy of Aaron Carson.*

Above: The Knoxville Beer Snobs, Rob Shoemaker and Don Kline, showcasing their commitment to the craft beer scene. *Courtesy of Rob Shoemaker.*

Left: Blackberry Farms' bottling line ships artisan bottles across the United States. *Courtesy of Aaron Carson.*

Above: The launch of the Brewly Noted Beer Trail. *Courtesy of Creative Energy and Karen Jenkins.*

Right: One of the original godfathers of the East Tennessee brewing community is Marty Velas with Fanatic Brewing. *Courtesy of Aaron Carson.*

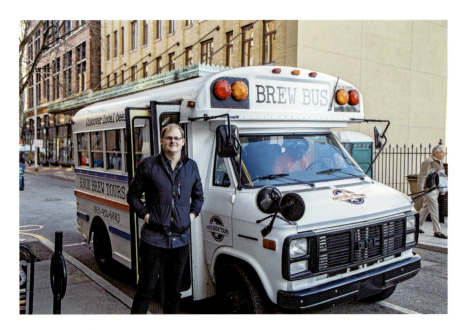

Above: Zack Roskop, with Knox Beer Tours, provides an insider's and door-to-door knowledge. *Courtesy of Zack Roskop.*

Left: Bristol Motor Speedway and the Bud Girls. *Courtesy of Holston Distributing and Mike Hubbard.*

Above: The Tennessee Championship of Beers is Tennessee's first commercial brewery and cidery medal event. *Courtesy of Joseph Mayes.*

Right: Gypsy Circus Cider chilled naturally with snow. *Courtesy of Aaron Carson.*

Below: Homebrewers reign supreme at the local craft beer festivals. *Courtesy of Sheri Hamilton.*

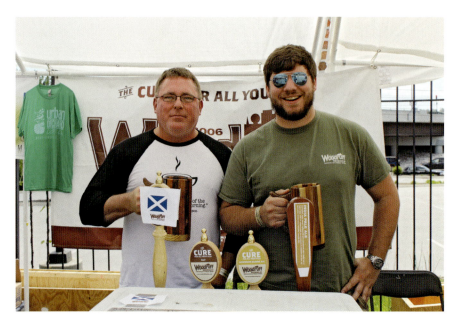

Woodruff Brewing Company shows its longevity and commitment to the community. *Courtesy of Alison Hill.*

Changing out kegs at Johnson City Brewing Company. *Courtesy of Kat and Eric Latham.*

Brewhibition, Knoxville's 1920s-themed craft beer festival, brings out flapper girls and revelry. *Courtesy of Alison Hill.*

Bristol Brewery on opening night. *Courtesy of Aaron Carson.*

Smoky Mountain Brewery's conical fermenters dot the landscape. *Courtesy of Aaron Carson.*

The Thirsty Orange Brew Extravaganza explodes with a litany of craft brewers from around the region. *Courtesy of Sheri Hamilton.*

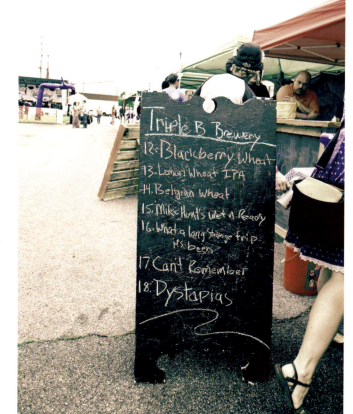

Above: Blount County Homebrewers representing with bikes and beers. *Courtesy of Shawn Kerr.*

Right: Making the transition from homebrewing to pro-brewers, the folks at Triple B Brewery show their lineup. *Courtesy of Sheri Hamilton.*

Left: Bluetick Brewery's bluetick takes a snooze at the brewery. *Courtesy of Aaron Carson.*

Below: Gypsy Circus Cider Company celebrates being the original craft cidery with its all-natural cider. *Courtesy of Stephanie Carson.*

Now, the scheme might have gotten even more brilliant, with Alliance's built-in active community. Morton and his drinking, running and cycling pals can do just that without needing to put a sign on the door.

Duo Puts Heads Together to Open Balter Beerworks

Brewery: Balter Beerworks
Where: 203 West Jackson Avenue, Knoxville, Tennessee 37902
First Pour: February 2016
The Story: *Balter* is a verb that means "to dance without particular grace or skill, but with enjoyment," and while the dancing abilities of Will Rutemeyer and Blaine Wedekind are yet to be determined, it's fair to say the Knoxville duo were dancing in the beginning of 2016, when they finally opened their brewery.

Rutemeyer, the head brewer, and Wedekind, the vice-president, got into the brewery business much like many others do, behind the simple idea of "how awesome would it be to start a brewery?" While this idea was festering, Knoxville's beer scene was rather select, without many options. Though this differs from the scene today—with all the breweries that are opening up in 2015 and 2016—they still see a need for what they're offering.

For starters, their location is prime, with the massive piece of land right in what they expect to be the thick of it in downtown Knoxville. "We're repurposing this old garage, substation downtown," Wedekind said. "It's a great spot, but it's a really tricky spot. It's a full acre downtown. That's a huge amount of land for downtown."

The tricky part isn't the building. That part is easy, and the early designs excited the owners and anyone else they showed, but it's the earth around them that is difficult. A hill surrounds what will be Balter's brewery, but it's not as easy as bringing in some earth-moving machines, because the owners are not dealing with dirt and mud as much as they're dealing with a few huge hunks of solid rock. Going at the side of the hill opened that can of worms when they'd initially hoped to add a quick two thousand square feet to their operation. But after finding the rock, they had to reconfigure everything, pushing back what they hoped would be their opening date.

"Once you get a backhoe in, you hit a rock, which is one of our setbacks is that we hit a big rock behind it and had to reconfigure our building around this big rock," Wedekind said. "That was another month's setback."

Frustrating? Yes. But enough to stop them from completing their mission? Absolutely not.

What they want to do is give Rutemeyer the brewhouse and environment he desires to run amok, giving Knoxville and its beer-loving tourists something to talk about and enjoy. And the two founders of Balter want to be there to talk about it with them. Initially looking at a production brewery model, they settled against that idea, looking to get more involved than that.

"We want that kind of control and we want the freedom to be able to do tastings and be able to explain to people what they're tasting and why it's that way and where it comes from," the head brewer said. "That's our spin on things."

In doing so, Rutemeyer is going to strive to make what he likes: traditional styles on the seven-barrel system and one-offs on the ten-gallon side system. The ability to experiment, take risks and possibly make mistakes on the smaller system is important to the head brewer. "You can get in there, find a thread and maybe tug on it a bit and find out what people are into," he said.

There are plans to have a restaurant on site and a bier garden atmosphere. With that, Wedekind says, the community feel they're going for will come along. They have fun doing what they love, and they want to share that with their guests. These guests might be sitting under the canopy that covered the previous business's fuel pumps—a novel and unique idea for the breweries that are opening up.

Having removed the tanks and made it smooth sailing for the Balter guys putting in their brewery, there isn't any worry about environmental issues with the previous chemicals used there. And the pair really like the available clientele they will try to entice with Rutemeyer's traditional styles and whatever else they come up with on their pilot system.

Rutemeyer sees nearby beer-loving city of Asheville as more similar to Knoxville than different and believes that Knoxville can continue to move in that direction instead of having a significant portion of its population head over the state line for beer every weekend.

In having so many other breweries and beer joints opening up around the Knoxville and East Tennessee area, the Balter guys don't feel like they're hitting a saturation mark, which is the same impression they're getting from other brewers. Getting opened up is more than half the battle.

"In the meantime, Knoxville's beer scene is exploding, so hopefully that will help," Rutemeyer said. "There's a lot of good people and a lot of good things happening. I just ran into Scruffy City's brewer again, and he's feeling good again."

A Fermented History

The Balter Beerworks crew nears completion of its Knoxville location in early 2016. *Courtesy of Blaine Wedekind.*

In an area where many of the older, more traditional brewers have set the tone, ridden through the hard times, weathered the storms and kept the local industry going, Rutemeyer and Wedekind join Logan Wentworth at Scruffy City Brewery, among others, as the next generation of Knoxville-area brewers.

World-Class Resort Adds World-Class Beer

Brewery: Blackberry Farm Brewery
Where: 1471 West Milliers Cove Road, Walland, Tennessee 37886
What's on Tap: Mole Dubbel, Reposada Saison, Prickly Pear Saison, Summer Saison, Farm Ale
First Pour: February 2015
The Story: Blackberry Farm is known for its accommodations, spoiling its guests with its various offerings, be it a cottage, estate room or suite. It's

difficult for a traveler from near or far to spend time there without feeling like royalty.

The food and wine selection is just as well known as the lodgings. Its website boasts that Blackberry Farm "has been recognized as the #1 Hotel for Food Lovers from *Bon Appetit* Magazine and the #1 Food and Wine Resort from Andrew Harper's 2014 Hideaway Report." Breakfast, lunch and dinner are carefully constructed with tasty naturals from the farm's land, all considering the resort's location on the map.

With a wine cellar that is widely recognized as world class, overseen by a team of sommeliers led by Andy Chabot, it's no surprise that the farm scored a list of accolades nearly as long as the ever-blossoming wine list. The list includes ten years and counting of being named *Wine Spectator*'s Grand Award Winner, as well as earning the James Beard Award for an Outstanding Wine Program in 2014.

Through its successes, the bar continues to be set extremely high for anything else Blackberry Farm might want to add to its list of offerings, but that doesn't deter it from adding more and more. Most recently, with the help of local craft beer legend Ron Downer, Blackberry Farm went out, carefully selected and brought in a brewing system and brewhouse that can only be described as world class.

To go with this WM Sprinkman four-vessel, twenty-barrel brewhouse, Blackberry brought in Michigan native Daniel Heisler as its day-to-day operations guy and head brewer, making sure what it's pumping out is just as high quality as everything else around the farm. Heisler's background indicates that he's the right man for the job. He's worked with the resort's managing partner, Roy Milner, and his day-to-day crew, comprising experienced beer men John LeQuire and Tim Moore.

Knowing what he was getting himself into, Heisler carries with him a great deal of experience from up north in the colder climates, where he homebrewed for years before jumping up to work at several small breweries and then, most notably, for New Holland Brewing in Holland, Michigan. He worked under a fine mentor and a man he holds in high regard as a great brewmaster, John Haggerty, who was brewmaster at New Holland Brewing for about ten years.

In that time, Heisler said he worked with a tight crew to produce a fine brew. At Blackberry Farm, he works with another tightknit group to achieve the exact same goal in a slightly different fashion. He appreciates the "best and freshest you can be!" attitude Blackberry Farm takes with its approach to beer, wine, food and lodging.

A Fermented History

Blackberry Farm Brewery in Walland, Tennessee, attaches itself to a celebrated luxury hotel and resort and, since opening, has produced beer up to the same level of quality. *Courtesy of Aaron Carson.*

"We don't want to be restricted by anything at all, but we have a particular mantra that comes from the farm that's basically, 'this is about making beer that you serve at the table, with food, in a crafted way,'" he said. "It's meant to pair with something."

Bringing his Michigan ways to the outskirts of Knoxville, Tennessee, Heisler said he's getting the hang of the area well enough and enjoying digging his heels into the local, blossoming craft beer scene. His time at Blackberry Farm currently includes producing wort in the brewhouse, managing the fermentation cellar and packaging the beer on the bottling line, but expansion and an ever-changing list of seasonal brews in four categories—HistoricAle, SeasonAle, AgricultureAle and ExperimentAle—will certainly keep the man's hands full.

"We're putting in a lot of modern equipment and a lot of attention to detail with the styles that are really old," Heisler said. "You're not going to see us busting out a lot of IPAs or stuff like that. We're going to be working on some classic Belgians and table-friendly beer styles." Their collective plan comes from regular meetings with his crew, the on-site farmers, the chefs and the sommeliers, who join together and talk about things outside of their own disciplines to learn from each other and the grace of what they all do.

Adding to the typical elegance and grace of everything that's done at the farm, bottled beers are produced with the champagne-style wire cage and cork, which is different from what most others in East Tennessee are doing. But standing out from the rest has never been a problem for Blackberry Farm.

"We really don't even have our kegs in line yet," Heisler said. "We're focusing on our bottle conditioning because that's going to be the thrust of what we're getting into. We do all the champagne cork and hood business that works pretty well for us. That's a hard thing to do for us. We're doing it at a production scale, and we really want to nail it down and make sure we're watching our yeast. If we're not, it makes for bad bottle conditioning, so we keep it really fresh."

For the future of Blackberry Farm's brewery operations, Heisler sees no reason why expansion isn't in the cards but also said all of that will come at a natural pace, when he and his team get up and running at full capacity.

The building that houses their operation is a seven-thousand-square-foot rectanglar brewhouse with odd rooms for storage and possible future expansion. There's also a different address for a building half the size of their current brewhouse. This building is empty and could provide the space for any of their next big moves.

"We're going to be a full-fledged brewery like all the rest of the guys, but it's just going to be a little bit of time," the head brewer said.

Heisler is certainly on board with the goal to produce craft brews that will end up next to the farm's tables, but they're not simply keeping everything locked up and away from the general public's view. Though the price of staying at Blackberry Farm is higher end, to match the quality, there is an option for those who might want to experience its food with its craft beers.

Bringing in the Cavalry

Brewery: Blackhorse Pub & Brewery
Where: 4429 Kingston Pike, Knoxville, Tennessee 37919 and 132 Franklin Street, Clarksville, Tennessee 37040
What's on Tap: Barnstormer Red, Vanilla Cream Ale
First Pour: 1995
The Story: Sometimes a great idea blossoms out of simple geography, and that's got a lot to do with why Jeff Robinson decided to open up the Blackhorse Pub & Brewery in Clarksville, Tennessee, in the early 1990s.

A Fermented History

A military man stationed at Fort Campbell, just over the Kentucky border, Robinson left that part of his life behind him to head a few miles south to the nearby Clarksville, Tennessee. He and his wife, Sherri, soon opened a small pub, eventually adding the brewery component into the mix in 1995.

When beer was brought into the equation, the Robinsons decided to settle on the name Blackhorse, which is a throwback to the Eleventh Cavalry Regiment, which carries with it a long history, especially during the Vietnam War era.

Not long after this, they moved into the Knoxville and East Tennessee market, too, developing the business into a product that could be sold, which is exactly what they did in 2001.

In 2013, an old pal of theirs let them know the Knoxville location was once again available. It didn't take them long to decide they wanted it again and also wanted to tackle the endeavor in a different fashion.

"We went over there and decided to go back to Knoxville and put in the Blackhorse Pub & Brewery again in the same location," Jeff Robinson said. "Then, this time when we did it, we put a little bit more capacity into the brewery and we've added some distribution into the mix. We're not just doing the beer for the brewery there, we're distributing beer throughout the area and the Gatlinburg, Pigeon Forge, Sevierville, Oak Ridge—that area."

Now Blackhorse has a 10-barrel system with about 120 barrels of fermentation capacity available, with its eyes on getting the beer out to the public via bottle and can. As one of the few breweries currently able to put out high-gravity beers, it can already hang its hat on the idea that it's able to offer something different than most.

Its flagship beer list includes two very popular varieties: Barnstormer Red Ale and Vanilla Cream Ale, among other mainstays on the taps. A lineup of about two dozen seasonal craft beers will also cycle in and out of the taps throughout a given year, including a black IPA, a white IPA, a barrel-aged peach saison and an oatmeal stout, pushed out with nitrogen.

Having been around since the early 1990s, the Robinsons have seen shifts and trends in regard to the overall industry and what the customers want, so this move to distribution should be interesting. Distributing and, specifically, the area's distributors are seeing this influx of beer makers and only have so many taps at bars and restaurants and so much shelf space at grocery and convenience stores, so the fight for shelf space will continue.

"Part of the ability to survive is going to be maintaining viability in distribution," Jeff Robinson said. "The distribution guys are having a

The Blackhorse Brewery has been a staple on the brewing festival scene for some time. *Courtesy of Sheri Hamilton.*

meltdown because they just can't keep adding more and more beers all the time. I think that's going to be an interesting spot. How do you keep open lines of distribution when the distributors only have x amount of lines and x amount of warehouse and x amount of trucks and x amount of space? They just can't keep feeding more into the system." A bubble is possible in Jeff Robinson's eyes, but he likes the strength of the market compared to the shakey ground it stood on fifteen to twenty years ago.

Brewers are collaborating and teaming up, buying their goods locally and sourcing much better than they had been, which gives the East Tennessee craft beer movement more stamina and momentum.

That being said, Blackhorse's head brewer said not every brewery is guaranteed to survive, especially given the quality of beer. There's a lot of good stuff out there, but there's some bad stuff, too, and that goes a long way with the consumers. "Not everybody is going to have a good product," he said. "Not everybody's going to have staying power. There's going to be small brewer blood in the streets again."

A Fermented History

Community-Involved Beer Drinking at Its Best

Brewery: Bluetick Brewery
Where: 1509 East Broadway Avenue, Maryville, Tennessee 37804
What's on Tap: Lil' River IPA, River Sittin' Pale Ale, Just the Tip Red Ale, Brewer's Lament Belgian Dubbel, Sweet Holler Imperial Stout, Honey Speckled Hound American Cream Ale, Red Pecker Irish Red Ale
First Pour: December 2013
The Story: "All for beer, beer for all" is Bluetick Brewery's motto, and it's not just a cute thing to say, it's the way the brewery's founder, Chris Snyder, has formed and shaped the business. Cooperation was always an important characteristic for the restaurant man, who sought to give Maryville—a city about thirty minutes south of Knoxville—its first brewery.

He could have gone with the normal formula of his peers in the other parts of East Tennessee—find some investors and sit atop the brewery as its leader—but that wouldn't have fit in with his vision, which he explained outside Bluetick one night:

> *A co-op brewery is a brewery that's set up and built and ran by the co-op members. You see the bartenders that are in there tonight? They're co-op members, working for free, hanging out, enjoying the scene. All of our co-op members will come in and enjoy a couple of free pints for becoming members.*
>
> *We took that money that they gave us, that initial capital membership, which was $300, and used it to do improvements and website development to start building the business.*

Now the brewery has been going since 2012, when the idea took hold, built on the backs and enthusiasm of people who really wanted Snyder to put a brewery in Maryville. It is branded after the aptly named, locally famous dog Blue. Some of the supporters contributed in other ways, too, to get Snyder's business open, including funds given to Bluetick's Kickstarter campaign.

With such a strong outdoor activities following surrounding it, Maryville was ripe for a brewery, a place people could go after a hike or a fly-fishing adventure. Snyder and his team just had to get it there.

He remembers back to those formative years, when he was still working as a full-time chef to make ends meet and then popping over to the location of the brewery, constantly doing updates and projects.

The building he settled on was formerly the site of a printing press, which didn't lend itself very well to what he had in mind for the space. Snyder and

his team tore out everything, taking particularly large amounts of time to pressure wash the floors and tear things down as needed.

The plan was to provide the immediate area with a craft beer scene that didn't previously exist there.

Bluetick sought to accomplish two things at once: putting in the brewery and raising awareness about craft beer in general. Sure the team could feasibly put in a brewery, but to stay afloat and do well, they needed people to want craft beer and their beer specifically. "Not only did we have to build a brewery where there's never been one, but we also had to increase craft beer awareness and increase the culture," he said. "We change a lot of people over and find it fairly easy. The easiest beer to transfer is Miller Lite or Michelob or something like that, or something like a blonde. If we have a blonde on, people will always try that. And then they go, 'Well, I like craft beer.'"

And then, of course, Snyder and his team of co-op servers can bring them through the spectrum of beers they offer. For Bluetick, this spectrum includes a variety of ales all the way up to an imperial stout.

Chris Snyder, *left*, poses with co-founder of the Bluetick Brewery, Blue, who sits in the middle. *Courtesy of Sheri Hamilton.*

A Fermented History

Not only do Snyder and his wife, Sarah, take a progressive route to staffing and developing their cooperative brewery, but they're also very conscious about the way they use their resources, priding themselves on an increased level of sustainability. In doing so, their brewery can operate more cheaply, keeping the costs down, and of course, the environment wins.

Bluetick operates with 100 percent solar panel power, using high-efficiency hot water tanks; sends its spent grain to be used as feed and dog treats; reuses water for the heat exchanger; gets products locally for a fresher result and the use of resources nearby; and has a 100 percent rule against the use of additives, chemicals and preservatives, while only using kegs because of how efficient they are. This was exactly how Bluetick was designed: to make things run as smoothly and sustainably as possible.

Given the region's connection to mountain and bluegrass music and Snyder's career in the restaurant business, these two elements are huge for what Bluetick does. On Friday and Saturday nights, Bluetick brings in music and food trucks to give the crowds what they want.

Just like the growth of breweries and craft beer, portable meals coming off food trucks are also seeing a rise in popularity, and Snyder, a food guy, will be damned if he doesn't see his customers have a way to fill their bellies or hear a nice song if they want.

Pairing beer with food is something Snyder's done for some time, but he doesn't discount the effect it has on his customers, always conscious of the way they're coupling the two indulgences.

Taking a Scientific Approach to Craft Beer

Brewery: Cold Fusion Brewing
Where: 4711 Morton Place Way, Knoxville, Tennessee 37912
What's on Tap: Dark Matter Stout
First Pour: Yet to be determined
The Story: For all intents and purposes, most brewers featured in this book should rightly be categorized as nerds of their craft. This is, of course, a term of endearment applied to beer makers who know the ins and outs of beer production, who have magazine subscriptions to keep abreast of all the innovations in the field, who have applications on their phones to log and rate every beer they've tried and stay up with their fellow beer nerds to see what they're trying and who generally soak in every bit of information related to craft beer. Knoxville's Isaac Privett's geek-dom is not different, but he might

go a step further, developing his love of craft beer and its production into a brewery based on these beer-nerd principles.

In the beginning of 2016, Privett and his two brothers opened Cold Fusion Brewing, combining their love for brewing with their love for science. "My slogan is cold brews, fusion and flavors," Privett said. "I make beers that are slightly outside the norm, but I want a balanced beer even though it's different."

Oak Ridge National Laboratory—the site where the Manhattan Project was put into play to develop the atomic bomb during World War II—is just a forty-minute drive from Cold Fusion's north Knoxville location, and Privett said that had a lot to do with the theme of the brewery—that along with his early introduction to higher learning and science, specifically.

"I have a little bit of science background in college," he said. "I grew up in the Sevierville area, then I went off to college for a few years. Instead of finishing high school, I went off to college instead. I got an associate's degree when I was eighteen. So I was doing aerospace engineering and biology and stuff. Plus, we have Oak Ridge right down the road."

Privett's brews have titles like Dark Matter Stout and Sub-Atomic IPA. To get Cold Fusion brews, customers are going to have to go to retail stores, as there aren't currently any plans for a tasting room at the 1,500-square-foot facility in north Knoxville, where the four-barrel system can be found. Because it sits about 80 feet from a church, Cold Fusion's hands were tied in regard to a tasting room because Tennessee law currently says that the distance between the two organizations needs to exceed 300 feet. So for that, the brewery is going to work with what it has and is going to self-distribute at first and then consider a move to working with one of the major distributors. "My plan is to do that down the road, but it's got a lot of extra permits you have to get through the state," the owner said. "So I kind of took it one step in a time."

Privett may admit to a bit of a lack of business experience, but he makes up for that, as any mad scientist worth his or her weight in manganese would, in innovation. And by saying that, Privett is going to save money by being thrifty and adventurous with his resources.

Some examples of this include, of course, having his two brothers work with him, which is beneficial in multiple ways. Who can he trust more than his own brothers? Not only do they have a certain level of loyalty to the business, but he can also work them longer hours if needed. Both will be helping with the self-distribution and logistical sides of the operations, but bigger opportunities are expected to come about, too.

A Fermented History

The Cold Fusion Brewing team, with Isaac Privett, *middle*, leading the charge. *Courtesy of Isaac Privett.*

Having strength in the way of farming, the Privett brothers are going to be looking at growing their own hops in the near future, keeping the process as locally rooted as possible and also cutting out yet another middleman between their business and the hops they desire. Plus, they can choose their own varieties.

Another local brewing element they've picked up is wild yeast strains, which are going to be helpful in developing beer. "I'm working on my own tiny little lab," Privett said. "This whole thing is kind of like my little baby, a steppingstone where I can just experiment, have fun and make good beers and try to do something interesting. It is a lab. We do have our own microscopes and centrifuges. I've captured a few wild yeast strains outside the breweries, some wild cherry skins. They're in my freezer right now and a really good saison yeast."

The innovation doesn't stop there. Privett is also working on a squirt bottle that can turn any boring lager or pilsner into a craft beer. Though it's still in its early planning stages, the Cold Fusion scientist likes the chances of that hitting the market in the near future.

To remain economical and environmentally conscious, Cold Fusion will also look into using milk as glue for beer labels so it can brew into recycled bottles, as well as putting out its beers in disposable kegs, which, he says, are theoretically reusable, something he plans to explore.

Yes, Privett says, there are a lot of craft beer options going into the Knoxville-area market, but with the different approach to what he's putting out, he sees a need for a beer off the beaten path. "There are a lot of craft beer drinkers in town that are looking for something besides the standard," he said. "They're looking for something a little bit different. I'm not worried about the amount of craft beers in town because I'm doing something different. There's enough little bars that want something different. If they don't want to carry my beer, that's fine. Someone else will."

The Crafty Craftsman

Brewery: Crafty Bastard Brewery
Where: 6 Emory Place, Knoxville, Tennessee 37917
What's on Tap: Hop Candy IPA, Salted Caramel Coffee Porter, Knoxville Pride English Bitter, Hawaiian BBQ Smoked Pale Ale, Cropduster Pale Ale
First Pour: December 2014
The Story: "You crafty bastard" was originally a term of endearment Aaron McClain used with his high school chums, joking about the fact that they were keeping their eyes on one another. But it didn't end there. It turned into the name of the brewery McClain opened in late 2014.

As is the case with many great ideas, there was a woman involved in the creation of what would be Crafty Bastard Brewery. McClain's girlfriend bought him his first brew kit for Christmas one year, and he was off and brewing his own brown ale in just about no time.

He wasn't all that impressed with his New Castle–like creation, but it was drinkable, and he loved the process. His enthusiasm had him move out of the kits and into the real world of homebrewing, where he'd get his own ingredients, which lit a fire in his belly to get crazy or, more aptly, crafty. "I'm one of those kind of people where if I get into something, I really want to do it," he said. Dipping his toe into those crafty waters, McClain started with a mango IPA and then a pine sprig ale, and he was off and running.

On the day we conducted an interview with the brewmaster himself, he was heading out to a property in Oak Ridge to handpick fifteen pounds of pine sprigs for his brewing, citing pine sprigs, not the needles, as the way to go when it comes to brewing. Needles, he said, are resinous, sappy and bitter, not characteristics of a beer he's very fond of.

A Fermented History

McClain spent five years homebrewing, having fun with his experiments and impressing the members of a local brew club he joined from the offset. How he got from an adventurous homebrewer to the man behind Crafty Bastard Brewery started in the aisles of McScrooge's Wines and Spirits in Knoxville, where he was browsing the liquid goods, doing his thing.

"There was a guy there who asked if I'd suggest anything," McClain said. "We chatted and he was like, 'Hey, man, I've got this beer club. Here's my number if you want to stop by this Thursday.'" He showed up to the club to find that it was a bunch of older gentlemen who love beer and used that as a way to get out of their wives' hair.

Being a part of the club for about four years, all while working as a local math teacher, McClain and his girlfriend, Jen, became tickled by the idea of opening their own brewery, though that conversation never left the two of them. They'd gone as far as to talk about what kind of funding it would take to get up and running but proceeded with their normal homebrewing and respective jobs as usual.

At one of the meetings, he brought his smoked pale ale and was talking about the citrusy notes that were coming out in a Hawaiian barbecue kind of way, and he was pleased with the result. One of the members of the club,

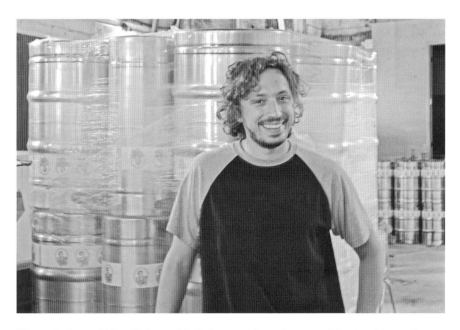

The crafty bastard himself, Aaron McClain, poses for a photo, suspiciously without a beer in hand. *Courtesy of Aaron Carson.*

Scott, was also pleased, enough so to nearly illuminate the room with a light bulb that went off over his head. After a few sips, the next question out of his mouth, directed toward the beer's creator, was "How much would you need to do this professionally?"

"Are you serious?" was McClain's response. "I told him to give me a week, and I spent the next week crunching numbers and doing all this other stuff, and of course I was way under budget, but I got back to him." Knowing the potential investor and friend was pining to be a part of a brewery, McClain offered him the chance, and the plan has been unfolding ever since, with Scott, McClain and Jen calling the shots.

That's not to say everything has gone exactly according to plan—city and state regulations often make McClain and his team scratch their heads for solutions—but what's made the process easier is the amount of favors and kindness the crafty bastard himself has received in pursuing this endeavor. Aside from the funding opportunity, he's also scored a free walk-in cooler unit, which would have cost several thousand dollars; legal help on the cheap from a friend; and generally a gang of friends who've helped invest their sweat in making the brewery come together. He jokes that he's going to be giving away free beers to his support staff for some time, which is fine by him.

As a night person and someone looking to make enough money to keep the lights on, McClain said he's going to make good use out of the area consumers who are under thirty-five years of age. Crafty Bastard is located in a younger person's part of town, with young professionals and service area people often looking for a nightspot.

McClain wants his brewery to be that spot, using all two thousand square feet of the old warehouse and tasting room to provide live music, albeit it will more likely be coming off an acoustic guitar than an electric. There will be eight to ten taps with three or four standard beers available and a rotation of the rest, maybe even including the non-alcoholic stuff McClain's made and become quite popular for.

Though he makes a root beer, the brewmaster has produced a mango curry ginger ale that got people buzzing wherever he's served it.

Starting off with a three-barrel system courtesy of Bubba's Barrels, the brewery's main crafty bastard is ready to take his adventurous brewing style professional. This setup is a bit smaller than some of the other brewers' systems.

It's the playful way McClain puts together his recipes and beers that sets him apart. With so many of those peers hanging on to traditional

brewing styles, be they from Belgium or Germany, McClain uses them for the base of beers. Some of the specials he's come up with are his 10.5 percent alcohol the Crafty Russian imperial stout, his Falcon Punch and his Tessellation IPA.

Getting Fanatical about Knoxville Beer

Brewery: Fanatic Brewing Company
Where: 2727 North Central Street, Knoxville, Tennessee 37917
What's on Tap: Tennessee Blonde Ale, Pale Ale
First Pour: February 2015
The Story: If presented with the opportunity to start a Knoxville-area brewery with one head brewer in charge of it all, it would be hard to imagine Marty Velas not making the short list of top picks. And that's just what happened to Josh Martin when putting together his team for the Fanatic Brewing Company leading up to its mid-2015 opening.

With the goal of putting out several delicious and very sessionable beers, Martin, Fanatic's president, built Fanatic around Velas's knowledge of brewing and craft beer, which circles the globe and dates back to the 1970s.

"We know what Marty can do with his brewing, because he's been brewing for thirty years," Martin said about his brewmaster. "There's zero question that the dude can brew." Martin would have no luck finding anyone in Knoxville's beer scene to disagree with him on that.

Velas isn't a Knoxville native, having grown up and started brewing in California at the age of seventeen after having gone on a trip to Europe, the land of his people. "I started homebrewing in 1978 after a trip to Czechoslovakia, where my family is from," Velas said. "I tasted the beers over there and really fell in love with them."

The law of the land was that homebrewing wasn't legal for anyone, regardless of age, before the year 1979, so Velas, along with a few others, broke the law without any trouble because the anti-homebrew laws weren't very well enforced.

Velas started with a little mail-order beer brewing book, a pamphlet that would kick-start the adventurous mind of that young brew lover. He was magnetized to like-minded people and joined a brew club called the Maltose Falcons, which has the designation of being the oldest homebrewing club in the United States, surviving so long that it recently celebrated its 140th anniversary in 2015.

He didn't exactly realize it at the time, but with his club, Velas was cranking out world-class craft beers with fresh ingredients, using big pots purchased in restaurant liquidation sales.

Craft beer brewer wasn't exactly an approachable career path, so Velas went to Cal-State Northridge for a pursuit of electrical engineering, working with a focus on aerospace for a number of years until the mid-1980s.

At that time, breweries were about to begin popping up, and Velas found himself a spot. His engineering was a turn-on for his employers, and of course, he was very well versed in the ways of brewing.

After doing a journeymanship overseas, he came back to find a brewmaster position waiting for him. Seeing some of the beers he was making get ripped off, he agreed to develop and design new beers for the breweries needy of his craftsmanship, which in turn opened more breweries in these beach communities.

Continuing on this way of consulting and designing, Velas helped with equipment and product formulation, an aspect of the industry he said he enjoys. "I did that for seven years," Velas said of that part of his career. "I had my hand in at least 250 breweries. And that's globally, because I was involved in the very first one in Japan in 1994 when they passed the law. This man who made some of the best sake in Japan wanted to do his own thing. He saw the craft beer movement in the U.S. and was instrumental in getting the laws changed in Japan." So Velas helped him open up his own place.

In his consultant work, Velas found his way to Knoxville to work with the Copper Cellars group to put in brewpubs.

"It looked like a nice place, so I started a family here," Velas said. "We just fell in love with it."

Velas's job was to make sure the restaurant group had enough beer to supply their locations, and he accomplished that, working with them for about eighteen years.

Velas said he was ready for a new challenge, with energy about him and wind in his sails, which ultimately landed him a gig with Fanatic. "Josh Martin had bought a building and intended to get into it, the craft brewing industry, having owned and operated several other successful businesses. So he's got that acumen, and the time and the energy and the karma was perfect."

Martin, a homebrewer since the age of seventeen, had a vision for the beers that were missing from stores' shelves and wanted to remedy that with the help of Knoxville's most well-respected brewers.

"Fanatic was a brainchild about five years ago, which got set in motion about two years ago when we purchased the building," the company's

A Fermented History

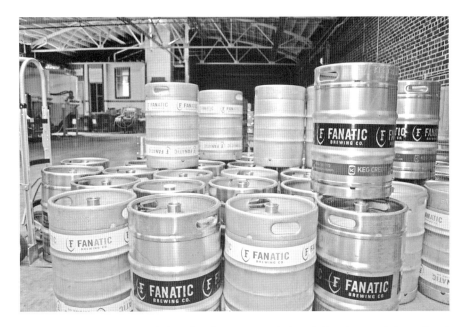

A pile of kegs from the Fanatic Brewing Company await the missing element: being enjoyed by of-age craft beer lovers. *Courtesy of Aaron Carson.*

president said. "Marty came on about a year, year and a half ago. I knew what I wanted to make. There are a lot of beers out there that are way out there. They're great, but they don't sell a lot of them. So when I looked at the shelves, we didn't see anything blonde. We saw Carolina, but everything else was really hearty beer. If you wanted a lighter fare, you had to go with Amstel."

Enter Tennessee Blonde Ale, Fanatic's flagship beer, which is very drinkable and quite an aid to University of Tennessee football games and the local bar scene.

"We've got a thirty-barrel brewhouse. We can put out, this year, five thousand barrels," Martin said in the middle of 2015, with his eyes on growing the ability to distribute far and wide. It will be coupled with several other Fanatic beers, but Martin has been working on the hoppy beer, which is expected soon.

Moving tons of Fanatic's beers is the goal moving forward. Currently, there aren't plans to put in a tap or tasting room, as Martin's crew is going to use the building to accomplish the goal of moving product. "We're a factory," Martin said. "We don't want a tasting room. We don't have room for it. We might put something outside down the road."

Velas is less sure they'll be looking into putting in a taproom or bar for the public in the future, saying they've got a plan to produce beer to keep up with demand. He doesn't rule out the idea of having a tap or tasting room but says it's simply not in the cards.

Expansion into adjacent properties, being involved in festivals or even starting out with growler fills could come in the future, but as the brewmaster and president said, they'll let that all come naturally and as needed. Not to mention, Velas said Tennessee's laws are beginning to grind their gears toward progress for people in his position. Marty Velas entered 2016 as the sole owner of Fanatic, and he continues to build on his brewing legacy as one of the godfathers of East Tennessee brewing.

Springing into the Brew Scene

Brewery: Last Days of Autumn Brewing Company
Where: 808 East Magnolia Avenue, Knoxville, Tennessee 37917
What's on Tap: Southern English Ale, IPA, Saison
First Pour: Early 2016
The Story: Like many who get into the craft beer business, which could—given the movement seen around Knoxville—be called an East Tennessee renaissance, Mike and Tracy Frede are looking at their opening of a brewery as a way to leave the boring corporate world behind them.

They'd moved to the area in the mid-1990s and settled in. Having picked up a brew kit around the same time, Mike Frede always tinkered, on and off, with making his own craft beers.

Admittedly, over the course of more than twenty years, he'd never brewed with or for anyone else, always going it alone and focusing his efforts on the traditional styles rather than fruit beers and crazy seasonals.

The Fredes have been in and out of what they estimate to be more than 150 breweries over the years and love where the journey has taken them, always giving them the chance to try something new. "This started as a hobby for us, and we've been to close to 150 different breweries," Mike said. "We love when you walk in and are unfamiliar, come back and it's completely different." They like that ever-changing characteristic of breweries, that they're constantly changing the flavor styles of their customers.

Now they plan to open up and focus on growing the business through self-distribution and a taproom. A multi-layered career history that includes lots

A Fermented History

The Last Days of Autumn, among other places, cut its teeth serving beer at festivals across Tennessee. *Courtesy of Aaron Carson.*

of work in the restaurant industry has Last Days of Autumn's head brewer's gaze firmly set on a brewpub-style location that serves up food.

Self-distribution will give the couple the opportunity to play on their feet and develop the business as they see fit. "We'll see how it's going in the first year and a half and then kind of decide where we want to take it," Mike said. "With all these places opening up right now, we don't know how many there will be next year."

KEEPING IT LEGIT

Brewery: Scruffy City Brewery
Where: 28 Market Street, Knoxville, Tennessee 37902
What's on Tap: Kolsch, IPA, Stout, Amber, American Pale Ale, Belgians, Saisons, Seasons and "whatever they feel like brewing"
First Pour: Early 2016
The Story: Enter Scruffy City Hall at 28 Market Street in Knoxville and you'll find yourself in a place like no other. Through a long but not super-wide hallway-like bar, you move into the back section of the event space with an old-timey stage situated in the back. On this stage, depending on the evening or the event, you could have a film showing, a concert, a comedy

Scruffy City Hall Brewery, located on Market Square. *Courtesy of Aaron Carson.*

show, a dance extravaganza, a play, a public meeting or a trivia contest. Anything, really, could be taking place on the stage, but like the phantom of the opera, below the stage, a man works.

That man is Logan Wentworth, and he's the head brewer of Scruffy City Brewery, which is slated to open in early 2016. A fixture at East Tennessee beer festivals and events, Wentworth carries with him respect for his ability to brew, as well as his proclivity to be daring, fun and adventurous.

This bodes well for people looking for something exciting in their pint glasses. His journey to his first big head brewer position is interesting in the sense that he went from a guy playful with his homebrewing under the name Legit Brewing to becoming a somewhat recognizable local sensation in the beer scene.

After a brief hiatus from the Knoxville beer game, Wentworth went back to it, found his worth and is brewing under Scruffy City Hall's stage like a madman. This opportunity was offered by his friends at Scruffy City Hall who spitballed this idea to him, allowing him to open up his brewery in the event space and bar.

"Originally, we were going to try to fit a ten-barrel down there," he said. "Then, we went back down to seven and thought that maybe we could still do it. Once the bar started getting up and running, we started to realize just how much of that space we would need for the bar. It slowly got downsized and downsized. Now, we've got this two-barrel system, which is kind of perfect in my opinion. Now I've got so much freedom to play and experiment."

Knoxville's Anchor Brewery

Brewery: Saw Works Brewing Company
Where: 708 East Depot Avenue, Knoxville, Tennessee 37917
What's on Tap: Rocky Hop IPA, Pale Ale, Brown Ale
First Pour: August 2010
The Story: Adam Palmer, though the top dog at Saw Works Brewing Company, recognizes his position as one of several very important components to the operation. After a quick name change from Marble City Brewing Company to Saw Works Brewing Company, the brewery hasn't looked back.

With a friendly foothold on the local and regional beer scene, Palmer does his share, which includes payroll, insurance, logistics and the like, but he does not do the brewing, which is done by another uber-important

part of the Saw Works machine: Will Brady and his assistant brewer, Jeff Adams.

Brady and Adams are both graduates of Knoxville's unique educational opportunity for brewers that takes place at South College in its Professional Brewing Science program under the famed leadership of Dr. Todd White. They work with Palmer to put out a consistent product, something that's extremely important to the company's president, almost more so than anything else.

That doesn't mean they're treated like robots at Saw Works, though, as they're encouraged to constantly challenge themselves to do something different, earning a chance to author the brewing company's next best beer.

"We have our flagship beers on, and we also have what we call our Rough Cut series, which we make on our pilot system, forty gallons at a time," Palmer said. "We put it in the tasting room, really to just get customer feedback. Sometimes we don't produce them again. Sometimes we'll put them in the tasting room. If we get really good feedback on it, we have had that beer turn into a seasonal that we've put out on the market."

Brady, Adams and Palmer don't complete the full Saw Works team, as they're joined by Ashley Taylor and Jeb Whitley, who act as the company's sales representatives, heading east and west of Knoxville, respectively. Myles Smith oversees the canning operation, and Jordan Skeen, who is the company's listed cellar person, join the ranks.

Johnny Miller is the man behind the bar in Saw Works' tasting room, holding an important position. His goal, from day to day, is to provide quality service, of course, but also to accomplish the mission of converting the non–craft beer drinkers to the products Saw Works offers. Palmer likes what he sees in Miller.

"He does a very good job," Palmer said. "It's hard to identify people who are walking in and trying craft beer for the first time. The first question is, 'What do you drink now and what do you enjoy now?' We don't want to push a beer in front of you that you're not going to like. So we always try to find where their tastes are and conform to the beers we have that's closest."

Looking at the way the market has played out in recent years, with craft fighting back against the stranglehold the big beer producers have had on the overall market, Saw Works joins with its peers in trying to win over those beer drinkers who aren't used to something as bold and out of the box. For that, Miller's job is all the more important because he is possibly opening up a whole new kind of clientele.

A Fermented History

Marble City Brewing Company showcasing its heritage. *Courtesy of David Lay, Adam Palmer and Johnathan Borsodi.*

Take the Rocky Hop IPA, which for obvious reasons could catch the eye, or ear, rather, of University of Tennessee sports fans, who believe the song of that same name is as important as the team itself.

Palmer admits that Saw Works is stepping out of its usual ways with Rocky Hop, in the sense that while its eyes are always on the horizon, trying to make sure each of its beers resonates in St. Louis and Chicago as much as it would around Knoxville, this isn't the case with the IPA.

As the brewery moves toward packaging, it's going to go with a Knoxville-centric approach while still considering how it's accepted outside of Volunteer country. "When we do package our beer Rocky Hop, it will be a Knoxville package, and there will be a Knoxville package and then a rest-of-the-world package," Palmer said. "The Knoxville package will be orange and the tailgate beer for the Vols, and in Tuscaloosa, it'll just be a damn good IPA. And I don't care if they shoot it with their guns. They're still paying us."

What it is, is traditional and sessionable—qualities Palmer sees as important to the football fans who might have traditionally kicked back a six pack of beer from a major distributor as opposed to anything Saw Works puts out. But with a name like Rocky Hop coming in a bright UT orange sleeve, he knows he can at least get their attention.

Another attention-getter for Saw Works, at least in the brewing world, is the system on which it brews. The twenty-five-barrel Peter Austin brewing system was designed to brew English-style ales, having been installed by the folks of New Knoxville Brewing Company when the building was under previous management. Some of the old system's quirks make it extremely hands-on, man and labor intensive.

Cleaning after a long day of brewing at Saw Works. *Courtesy of Aaron Carson.*

"We flip all the switches and turn all the levers," Palmer said. "There's no automation in the process at all, which is good and bad. The brewers like having all that control, but at the same time, you lose some efficiencies and it's going to be quicker if you had automation. It is a unique system."

Alan Pugsley, who was Austin's protégé, sold and helped install the system and, until his recent death, carried with him a large portion of microbrewing history.

Palmer knows he has a unique system for making beer and appreciates the history but doesn't completely rule out bringing in a new system altogether. He hopes to move toward a coveted automated system, which would change quite a bit at Saw Works. Currently, the idea of upgrading the Austin system just wouldn't do, and in a few words, Palmer explains why: "If we're going to automate, we're going to get a new system. You don't turn a Ford Pinto into a Corvette. It's just not going to happen."

A Fermented History

German Beer Invades Knoxville in a Big Way

Brewery: Schulz Brau Brewing Company
Where: 126 Bernard Avenue, Knoxville, Tennessee 37917
What's on Tap: Lager, Bock, Double Bock
First Pour: 2016
The Story: So many brewers in East Tennessee and across the United States have pursued their dreams to open a brewery because of an informative experience they had while drinking beer overseas. Trips to beer-centric Belgium and Germany are common for beer lovers and often result in the idea to take what they've learned and apply it to the United States.

Where as many American brewers often try to bring a piece of Germany stateside through their beer, Knoxville's Schulz Brau Brewing Company started as a German brewery. The brewery's co-owner and head brewer, Nico Schulz, is a native of Germany and has seen a lack of traditional beers from his homeland in the Knoxville area.

And who better than a beer-loving, United States–trained German to supply East Tennessee with these traditional styles and the right bier garden atmosphere? While he recognizes Schulz Brau—the company he heads with his brother, mom and dad—as a piece of the Knoxville craft beer puzzle that's currently being assembled, it's the lack of one specific style of beer and the conversations he's had with other beer folk that let him know there was a need.

"As far as breweries go, we had Saw Works and then no really other breweries focusing on lagers," Schulz said. "We had the typical American pale ales, IPAs, brown ales, which were great—I just missed my lagers. I feel like there was a niche for it. Every time I talked to people, they really liked a German brewery coming to town. The German bier garden, that's what we're going for."

Schulz, who grew up in a small town in northern Germany near Hamburg, laid out just what he's talking about and looking for in the brewery. There will be a great outdoor seating area surrounding a waterfall and many trees, something Knoxville's been lacking in the co-owner's eyes.

Wanting his customers to be able to get a glimpse of the brewing process, there will also be a big, curved, glass wall that will allow the beer making to be seen. Lagers like the ones produced by Schulz need to be loved and given time to mature. The brewery's goal is to give them time to age so as to get the best of them. This, as is the case with the rest of the brewery's beer, or bier, list, can only come about through the use of the finest and freshest

The beginning of Schulz Brau. *Courtesy of Nicolas Schulz.*

ingredients, which will also be emphasized in production on Schulz Brau's three-vessel, thirty-barrel system.

What will come out of the brewhouse might include some of Schulz's favorites from his repertoire, including his Munich dunkel, hefeweizen, bock, double bock and quite a few other different ones. Non-traditional beers will be explored and developed as well, though that emphasis will be placed on clean, consistent, German-style lagers.

His customers won't only get the opportunity to drink their way through Germany but also to taste traditional German foods. Though they've not opened with a restaurant, it is in the works for the near future.

Schulz actually has a formal education in food, specifically studying in Lexington, Kentucky, at the University of Kentucky, where he earned a degree in food science. As much as he studied food, he's always been brewing, too.

Back in Germany, he grew up working for a community brewery. He said each and every small town had its brewery, and they all self-distributed. Not pursuing this alone, he and his partners developed the brewery, and he

can now remove his constant involvement in Blue Stallion and develop this German bier garden brewery in Knoxville.

Having a different set of partners on this project—his mom, dad and brother—Schulz will be developing this family business, which he says has always been in the works for their ilk.

11
COMING SOON TO A TAP NEAR YOU

With both the appreciation for and recognition of craft beer continuing to grow, the number of new breweries continues to expand. Here is a short list of breweries expected to open in the near future. This is by no means a definitive list; it is more of a starting point in the evolution of East Tennessee brewing.

For the Brew and for the Friendship

Brewery: Chisholm Tavern Brewing
Where: Knoxville, Tennessee
What's on Tap: Misty Melon Watermelon Kolsch, Samora Stout
The Story: Chisholm Tavern Brewing began life as a group of friends making homebrew in the garage of brewer Steve Dedman. Originally dubbed Friendship Brewing, the gang's fun hobby quickly took off. As the young brewery's reputation began to grow, notification of a possible trademark infringement forced the friends to look for a new name.

The original Chisholm Tavern was the first tavern in Knoxville, established in 1792 by Captain John Chisholm, a Scotsman and Revolutionary War veteran. The tavern quickly became a gathering place for the young town. It was located on Front Street (now Neyland Drive) along the Tennessee River on land sold to him by his friend James White, the founder of Knoxville. The home of William Blount, the first governor of Tennessee, was on property

adjacent to the tavern. Governor Blount was also a close friend of Captain Chisholm and entrusted many duties to him on the frontier of Tennessee.

Over 205 years later, future brewer Steve Dedman and his wife, Jennifer, moved to Knoxville from Oklahoma to attend the University of Tennessee. When the upstart brewery was looking for a new name, "Chisholm Tavern" was suggested, and it brought two worlds together. John Chisholm's grandson was the famous Jesse Chisholm, founder of the Chisholm Trail, which ran through the heart of Oklahoma. This famous cattle trail passed near the childhood homes of both Steve and Jennifer. The site of Jesse Chisholm's main trading post and his grave are also within a few miles. Jesse Chisholm is considered a founding father of Oklahoma. The name Chisholm seemed destined to bring together the Okies and their Tennessee friends. Friendship Brewing became Chisholm Tavern Brewing in April 2013.

Chisholm Tavern Brewing is known for bringing together flavors not normally associated with beer. The brewery's Misty Melon Watermelon Kolsch has been a perpetual fan favorite at beer festivals for several years. A newer addition to the lineup is Samora Stout, a chocolate-coconut-caramel stout that seems to remind everyone of a cookie with a similar name. The stable of beers is varied, from cream ales to Russian imperial stouts. One thing you can always count on from a Chisholm Tavern beer is big flavor.

If the long lines at the local festivals are any indication, great things are expected from Chisholm Tavern Brewing in the near future.

Geezers Brewing Exactly the Way They Want

Brewery: Geezers Brewing
Where: 133 South Central Street, Knoxville, Tennessee 37902
What's on Tap: Big Dumb Blond, Pale Bastard, Bitch Puddin'
The Story: It's no surprise that coming from such an explosive background as Geezers Brewing is a-OK with its sometimes-risky beer names. Big Dumb Blond, Pale Bastard and Bitch Puddin' aren't just attention grabbers because of their coarse language; they also grab attention because of the tasty beer inside their bottles.

Robert Noto, Tom FitzMaurice, Diane McDaniel and Jason Shields came together after working in the nuclear weapons industry to form the Knoxville-area brewery, set to open up in 2016. As much as they want buzz around their beers and want to sell them far and wide, they did get into the

Geezers taking a break at Barley's as they plan their brewery. *Courtesy of Aaron Carson.*

beer industry for themselves and hold true to their plan, even if it means rustling a few feathers.

"We've had fun with the naming," FitzMaurice said. "I think we all like edgy humor and we've picked names that we think are funny or make us chuckle and laugh. We've got that super edgy side to us. We haven't been focused on being politically correct, and I don't think we've thought about the impact of edgy names in terms of what's going to happen in the market. We've just been getting goofy with it."

It might be goofy, but it's also a business that they're currently pursuing. There isn't a taproom planned just yet, though that could come down the road. Right now, the focus is on getting moving with Geezers, which was a name played off their ages, with all of them having previous careers. From that came the structure of what would ultimately be Geezers, stemming out of the name they'd given themselves—Sin City Geezers.

The idea stems from about eight years ago, when these motorcyclists and beer lovers expanded into homebrewers and saw a possibility on the horizon, hoping to get out of their successful but extra stressful careers.

"Having a conversation with Bob, in 2008, 2009, we were going through a particular project that was taking a lot of time and getting stressful,"

FitzMaurice said. "We've all got graduate degrees and I think you'd put us in the smart people category, I'd hope. We're smart enough to make money that's less stressful, that's easier, that's not doing what we're doing."

As they ramped up their levels of seriousness and ideas, they were using GoPro videos and a blog site to talk about the beer they were drinking, where they were riding and anything else they thought was goofy and interesting. As they followed their "real" jobs to East Tennessee, they joined Knoxville Homebrewers Club and branched out from there.

When they took part in the local Brewers' Jam, they got some solid feedback from the festival's attendees and their fellow brewers. "We got great feedback on the beer, and our presence at the jam was significant," Noto said. Moving toward an official opening, they admit the question will be, "If people loved their beer when it was for free, will they be willing to pay for it?"

Home Is Where the Heart Is

Brewery: Great Oak Brewing Company
Where: Bristol, Tennessee
The Story: Justin and Jade Carson started their partnership while both were working in the U.S. Air Force. On their last assignment in Fairbanks, Arkansas, Justin got his big break and inspiration that would lead to Great Oak Brewing Company. Justin began an internship at Silver Gulch Brewing Company in Alaska, which was both Alaska's second largest and the most northern brewery in North America.

While working at Silver Gulch Brewing Company, he won fourteen medals for his recipes, along with focusing on the academic elements of brewing by taking the Siebel Concise Course and Oregon State University Brewery Startup Course. With all of the talent, the return home to Bristol began to fall into place.

Both Jade and Justin moved back to begin the journey of bringing their dreams to Bristol and to give back to the community what it had missed for so long.

The Underground Brewer

Brewery: Hexagon Brewing Company
Where: Knoxville, Tennessee 37902
The Story: Steven Apking, president and head brewer at Hexagon Brewing Company, recently had to settle on a big change that needed to occur for his dream of opening an official, full-scale brewery to come to fruition. Underground Brewing Company was the name Apking and his partners had used for years as Knoxville-area homebrewers, but when it came to licensing that name, things got a little tricky, and Apking had to decide if that was a legal battle he was willing to fight.

As much as it was a name for which he became recognized, Underground went underground, and the Hexagon Brewing Company emerged in its place, with the same promising and adventurous beers expected.

"It got to the point where I was spending a lot of my own money trying to use Underground Brewing Company, and it became cost prohibitive,"

Underground Brewing Company before the transition to Hexagon. *Courtesy of Stephen Apking.*

Apking said. "Underground doesn't have to die, we just can't use it professionally."

After a search and brainstorming process, they'd whittled the name choice down to Hexagon, for various reasons. A beekeeper, Apking rather respected the structural strength of things built with that shape, like the honeycombs built by those hard worker bees. To him, it stood as a symbol of strength and efficiency, which harkened back to his career in industrial manufacturing. What better way to build a sturdy business than on the back of a trustworthy hexagon?

And a new chapter in Apking's work with beer began. Not going it alone, he's partnered with Matt McMillan, who is a jack-of-all-trades type. Together, they plan on cranking out some big beers, which have always performed well at East Tennessee beer contests, but they're not stopping there. Whereas to Apking, Hexagon might have meant strength and efficiency, moving forward, it might also mean innovation and experimentation.

The pair plans on running with a taproom, as well as production facility, when they get up and running.

12

NOW IT'S A PARTY

Not to be outdone by other states that may have had a head start into the reemergence of this craft beer revolution, East Tennessee is doing exceptionally well in the party department. With so many craft beer drinkers finally hitting their strides and looking for a place to celebrate and enjoy these locally produced brews with like-minded individuals, professional craft beer organizations have stepped up big time to fulfill the people's needs.

The year 2016 will be a big one for Knoxville in that it will contain the twentieth installment of the Knoxville Brewers' Jam, which is just about the biggest day of the year for some of those involved with the area's craft beer scene. There will be twenty-six newcomers joining the festival in 2016, bringing the total of involved brewers to a whopping sixty-five, which is astounding considering the size of the area and how big of a blossoming movement is taking place in East Tennessee.

The Tennessee Valley Homebrewers, a collection of more than one hundred members in a forty-mile radius of Knoxville, take credit for helping get all these brewers' beers out to the festival's attendees. "We are also a large part of the annual Knoxville Brewers' Jam, having the largest tent at the festival, and are responsible for organizing and beer distribution during the festival day," the group boasts. And of course, it should boast, as it's a massive day of brewing celebration that brings out thousands, as Knoxville's original beer festival.

The Knox Brew Fest is another outstanding Knoxville festival that started in 2011 with Martin Daniel and co-sponsor Chris Morton of

For just twenty-five to thirty dollars a year, you can join the Tennessee Valley Homebrewers, and they're always ready to hand you a glass of something they've made. *Courtsey of Sheri Hamilton.*

Bearden Beer Market. It is another great craft beer festival for all of Knoxville to enjoy.

The Brewers Summit, put on by Superfly Fabulous Events in Knoxville in 2012, looked to add an educational element and a community discussion to the developing brewing business.

A recent addition to the Knoxville beer festival scene was the 2015 Brewhibition, also put on by Superfly Fabulous Events, which sought to share with Knoxville a spring festival, which it previously did not have. Brewhibition goes back to the 1920s, when beer popularity wasn't shared by so many, though it would ultimately survive and be a part of the craft beer magic that's happening today.

Stephanie Carson, with Superfly Fabulous Events, spoke about the differences between the two eras, which are nearly one hundred years apart:

> *In attitude, decor and approach, Brewhibition focuses on the 1920s era and the push to resist prohibition, and brings the attitude to modern day and the grassroots effort to embrace the craft beer movement. Brewhibition mixes Craft Beer and spirits with unique concoctions and creations that everyone can enjoy. Expect to take a trip back into the 1920s with swing dancing, a*

flapper girl vibe and the sounds of the Big Bands. The festival includes a thorough line up of brewers and cider makers, where participants can speak directly to the artist that made their product.

Tennessee Winter Beer Fest both gives beer lovers something to do in the cold and often festival-desolate winter months and donates proceeds to good causes. In the 2015 installment of the event, after earning 501c3 status as a self-standing nonprofit entity, the festival promotors decided to give to the area New Hope Blount County Children's Advocacy Center, continuing the initial goal of giving back.

In the first year, the festival raised $2,000 with the sale of tickets from the festival for New Hope, only to double its proceeds check through this past year, when it gave $16,000 to the organization with the help of area brewers who wanted to be part of the action.

Farther east, in the corner of East Tennessee, are a handful of other massively popular craft beer festivals: Kingsport's Tennessee Oktoberfest, the Thirsty Orange Brew Extravaganza, Racks by the Tracks and the Blue Hop BrewHaHa.

The Blue Hop BrewHaHa finds itself going into its third year in downtown Johnson City. It is closely tied to the Blue Plum Festival, which is the Tri-Cities' biggest festival. Bringing in approximately eighty thousand people to a downtown Johnson City festival is no small detail, and Superfly Fabulous Events and the city have partnered together to deliver in a major way on a beer party to remember within the Blue Plum Festival.

Carson explains why it's a really big deal to have such a party within a party, tying in tunes with craft beer—a perfect combination for an early summer event:

> *The event is a production of Superfly Fabulous Events in conjunction with Friends of Olde Downtown. Taking place in the open, green space of Founders Park, the Blue Hop BrewHaHa combines a craft beer festival with amazing national headlining music. Attendees can go to the Blue Plum for a great day of free entertainment and enhance their experience by coming to the Blue Hop for local craft beer and a national headline band.*

Following last year's BrewHaHa in Founders Park, the stage was literally set for Shovels & Rope, a national American folk husband-and-wife duo out of South Carolina.

A Fermented History

Even larger than the BrewHaHa is Johnson City's Thirsty Orange Brew Extravaganza, which has grown since its inception and, subsequently, moved venues to accommodate the festival's loyal following. Originally held at Mellow Mushroom, the Brew Extravaganza has since moved to Founders Park, where tents gather around for one of the most adventurous festivals in the area.

Brewing competitions, judged by the festival's attendees, pit brewers against one another in the Tennessee Championship of Beers. Because the festival takes place in the middle of the Tri-Cities' Craft Beer Week, the festival's organizers feel it's the perfect time to field "a need to recognize commercial breweries of the Southeast for the quality pints being served in the region."

And the word has spread on how popular of an event it is, as it's earned a Top 5 Festival in the U.S. designation from Beer Yeti, specifically because of that focus on artisan craft beer at the local level.

Nationally and internationally honored cheese expert Michael Landis is one of the experts brought in to up the ante of the festival's offerings. He's joined by other mixologist experts and foodies to offer festival attendees top-tier knowledge when it comes to what to eat when you're drinking.

"The Thirsty Orange offers craft beer tours at the festival led by local and national experts to educate participants on certain aspects of craft beer, mobile infusions to add a unique element to a beverage," Carson said. "Attendees will also enjoy great music, the shandy station and mixology bar along with an amazing atmosphere focused on one thing: great craft beer."

Kingsport's biggest yearly beer festival in recent years has been its German bier garden paradise—the Kingsport Oktoberfest. In its five years of existence, it's earned the reputation of being one of the hottest Oktoberfests in the United States, specifically being named in the top seven, according to *Paste Magazine*.

Yuengling, one of the big beer brands not referenced heavily in this craft beer book, steps up big to back the event, but to think it's less than craft beer focused would do the festival a huge disservice. German-style clothing, music and food take up a great bit of the theme of the festival, of course. It's no secret why so many brewers and beer lovers look at Kingsport's Oktoberfest as their favorite event of the calendar year.

As kid-friendly as a craft beer festival can be, the day-long event welcomes the youngins into "Das Kid Zone" and also showcases a weiner dog "Brat Trot" race. Along with the fun comes a great deal of notoriety, in that if you can make your beer stand out in such a competitive group of brewers, the recognition can take you places. In fact, brewers from Triple B Brewery and

Andrew Felty, who heads the Brewly Noted Beer Trail, is well known for, among other things, his infused beers. *Courtesy of Matthew Carroll.*

JRH Brewing have both said it was their success at Kingsport's Oktoberfest that gave them a lot of confidence to open up their breweries in the Tri-Cities.

One local cidery, Gypsy Circus, which operates out of Kingsport, made its debut at this year's festival, adding something new to the mix of an ever-changing artisan alcohol scene in the Tri-Cities.

Kingsport's Racks by the Tracks festival also contains within its schedule a craft beer tasting that seeks to bring in new craft beer drinkers, which is great for the commercial brewers who bring their new brews and flagships there to gain recognition. At the 2015 festival, there were more than seventy beers, some never before seen or consumed by the public.

Because the weekend-long Racks by the Tracks festival is family friendly and accessible to so many, the beer festival within it had to be as well, according to its founder, who spoke with Beer Yeti. "We wanted to make sure that our festival appealed to a large spectrum of people including families and others," said Kanishka Biddanda, the founder of the festival, which finds itself in its eighth year.

Being held on the three-acre Kingsport Farmers Market site opens up a lot of that access, even out of state, with breweries from twenty-one states coming in to pour for the festivalgoers.

13
LEADING TENNESSEE

Tennessee Craft Beer Month

Sometimes it just doesn't feel like your government is working with your interests in mind, but those involved with the craft beer industry in East Tennessee and across the state can't say that about the change of course that's happened in the past few years.

Jon Lundberg, a Republican state representative speaking for his constituents in the First District of Tennessee, made a huge impact in 2014 and 2015. He saw the writing on the wall in regard to the craft beer industry and all the business that goes along with it and really got behind some game-changing legislation. Lundberg said it was done with business in mind, referencing conversations he'd had in years past. "Some years ago, we started hearing about local craft breweries that wanted to open," Lundberg said. "And, frankly, I was irritated, because they wanted to open up on the other end of the street in Bristol, Virginia."

That side of the state line was more friendly to aspiring brewers in the position, considering the state's better business sense. Lundberg, having ten years of legislative work under his belt, simply didn't want to see them go, knowing what they were offering to the region and the state he represents.

With that, in March 2015, Lundberg sponsored a House Joint Resolution that would declare April "Tennessee Craft Beer Month," which would continue to give the state a month to build craft beer events around for years to come.

The Beer Barrel, a Tennessee/Kentucky football tradition. *Courtesy of the* Knoxville News Sentinel.

The most recent data, from 2012, shows an economic impact number of $445 million within the state. Approximately twenty-nine thousand people were employed by the industry that year. Four years later, seeing how many more breweries and brewery-minded businesses have popped up, it would

A Fermented History

April is Tennessee Craft Beer Month, celebrating all things craft beer. *Courtesy of Joseph Mayes.*

be silly not to assume that both those numbers have grown dramatically.

From Lundberg's perspective, how is any business-minded, craft beer–appreciating local politician supposed to look the public in the eye if he let an opportunity like that one slip by? He just couldn't.

"We tried to make some laws that are, frankly, common sense for the industry to grow in a natural way," he said. "I think East Tennessee has become a center point for a lot of craft brewers. When you look at Tennessee, I say we should highlight our craftsmen. It's easy. It's really not that difficult." Now those aspiring brewers and breweries have every reason to stick around and be part of the craft beer magic that will take place every April from here on out thanks to Lundberg's bright idea.

Tennessee Championship of Beers

Within the Tennessee Craft Beer Month is a long list of craft beer–minded events, all with the sole purpose of highlighting and promoting the craft. The 2015 Thirsty Orange Brew Extravaganza included the typical fun—commercial brewers and homebrewers strutted their stuff and made new friends and customers over delicious glasses of beer. But within the fun, a competition had finally been established, with competition director Matt Raby and Aaron Carson.

The Tennessee Championship of Beers—modeled after the Great American Beer Festival's yearly competition and offered at a much cheaper cost—came about to help pick the best of the best of the area's breweries.

That being said, it's not one brewery going against the other. A brewery's given beer is judged simply on how good it is. Not only is it the first of its kind in the state, but it's the largest commercial brewery medal event in Tennessee.

Kevin Mitchell, with the craft beer website Beer Yeti, spoke about the competition: Over thirty judges of various ranks, including several master level beer judges, assessed over eighty-five beers in various categories from

Internationally known beer, wine and food expert Michael Landis joins Pam and Erich Allen at a recent beer festival. *Courtesy of Pam Allen.*

pale ales to fruit beers. A testament to the quality of the competition and tuned palates of the judges was the fact that only four beers attained enough points to be awarded gold medals.

Brewly Noted Beer Trail

Tourism in the Tri-Cities, meet craft beer. I'm not sure you've been introduced before. It's about time the two made acquaintances, and that's just what local chambers of commerce and their respective convention and visitors bureaus have done in partnering up to invest in craft beer tourism, which is a win-win for everyone involved.

The name of this new endeavor is the Brewly Noted Beer Trail, which gives craft beer drinkers—already the kind to want to navigate around an area—extra reason to explore each and every one of the breweries in the region. How it works is simple: each of those business-minded entities sponsors a program that pushes craft beer drinkers to stay involved and

Brewly Noted Beer Trail's unique proposition as one of the nation's first multi-state beer trails. *Courtesy of Creative Energy and Karen Jenkins.*

fill out a trail log. The trail log has within its pages an area for each of the nine currently participating breweries, which are marked off like a passport.

"The Brewly Noted Beer Trail is the first time craft beer tourism has been introduced into Northeast Tennessee and Southwest Virginia," said Andrew Felty, Brewly Noted Trail director. "It is happening at the most opportune time with so many new breweries opening for business in the area. In 2015 alone we have had five breweries that have either just opened or will be open by year's end, all of which are a part of the trail. And this has happened all over the Tri-Cities, not just in one area."

Felty—who made the connection between Superfly Fabulous Events, a craft beer–oriented event management company in the Tri-Cities; the area's brewers; and the local business organization—said the entire thing came together for the sole purpose of helping this blossoming local, state and nationwide industry. He said:

> *What is really unique and exciting is that we have a partnership with three separate Visitor and Convention Bureaus (Bristol, Kingsport and Johnson City) that all agree that the recent craft beer boom in the region is something to take seriously. From the initial discussions about the trail, you could tell that this was an idea that was both exciting and potentially innovative.*

And innovative it is. Because it goes into southwest Virginia, it's categorized as the first of its kind in the United States.

Brewers from both Virginia and Tennessee collaborating for the Brewly Noted Beer Trail. *Courtesy of Creative Energy and Karen Jenkins.*

The founders of the trail call craft beer more than a beverage. They say it's more of a culture—a progressive, multidimensional culture that spans state lines and various demographics. What's at the center of it all is a collective mindset that a bunch of artisan craft beer lovers want to share their creations with the old, and the convention and visitors bureaus want to help them do that. For those who make it around to each spot on the trail, there are various pieces of swag to show two things: that they've had a chance to sample and visit each brewery and that all breweries involved are seeing increased business.

"The timing couldn't be more perfect to launch the Brewly Noted Beer Trail. This industry is growing at a remarkable pace, and we are in a prime location to take advantage of this opportunity," said Brenda Whitson, who serves as executive director for the Johnson City Convention and Visitors Bureau. "By supporting local breweries and promoting the trail, we are promoting job creation, the entrepreneur spirit and the quality of life for our region."

A Fermented History

Knoxville Craft Beer Week

The year 2012 was a massive one for East Tennessee craft beer, especially in Knoxville, where the beginnings of this craft beer revolution were starting to take foot.

The Knox Beer Snobs—Rob Shoemaker and Don Kline Jr.—were gaining popularity from the words they were throwing up on their blogs.

One entry, posted on June 12 that year, announces and highlights just how far the movement had come. The beer-loving duo were letting their followers know about something new that was ultimately the culmination of their hard work and interests within the beer industry:

> *Congratulations Knoxville! We made it. After countless pints, posts, tweets, untapped check-ins, visits to see our local brewers, beer gardens and restaurants/bars—not to mention rallying around anything to support the local craft beer scene; we have a week to celebrate. A week to call our own—our very own craft beer week. Pause for a moment—let that sink in. Think about all those times you traveled to other cities or watched longingly on Facebook as friends and fellow enthusiasts discussed what was happening in Asheville, Nashville, Milwaukee and Whoville. Now we have our own—it's our time to celebrate, to rally around our local purveyors of tasty goodness and enjoy each other's company over some good beer!*

Since 2012, there have been a series of beer-related events at nearly all of the small businesses that have propped up the movement and grown with it. And because these businesses have spread out across the Greater Knoxville area, events throughout the week follow the same pattern, hitting the downtown area, of course, but also going out as far as Maryville.

A full 2016 schedule showed the beer week to contain several events each day, with the grand finale taking place at the Knoxville Beer Festival.

Tri-Cities Craft Beer Week

Unlike other industries across the country, those involved with craft beer don't exactly see themselves in direct competition with the other brewers who are trying to do the same thing they are. Instead, many of them see

their similar interests as an opportunity for all to succeed rather than just one or a certain few.

In the Tri-Cities and southwest Virginia, this is apparent when you look at the Brewly Noted Beer Trail, where at least nine breweries signed up with area chambers of commerce to help one another out and give beer lovers a reason to stop by each and every one of their establishments.

It goes even further than that, though, with what was seen for just one week in April 2015 in the Tri-Cities Craft Beer Week, which is coincidentally a part of Tennessee Craft Beer Month.

To kick things off, well before the week of craft beer magic took place, six of the area's brewers put their heads together and worked on a collaborative project. What they came out with was the Tri-Local I, the first of what they expect to be a long series of collaborative brews to be put out each year during this holiday (of sorts) for the brewers.

"The whole goal is to have everyone—including people who may not be familiar with craft beer—get an understanding of what we have to offer here," said Stephanie Carson, who helps organize the week-long celebration with Superfly Fabulous Events, as told to the *Johnson City Press*.

Enough of the Tri-Local I brew was made so it could go around the Tri-Cities to be sold and appreciated throughout Tri-Cities Craft Beer Week. There were tap takeovers, specials, swag handouts, various events involving the elusive but very photogenic Keg of Greatness and, of course, a cumulative event: the Thirsty Orange Brew Extravaganza on the last day of the week-long beer party.

Michael Foster, one of the local originators with Jonesborough's Depot Street Brewing, said the week's long victory lap of a celebration would be both a whole lot of fun for thirsty craft beer drinkers and a sign of things to come.

Having seen the downside of the craft beer industry, he said it's events like the Tri-Cities Craft Beer Week that show him that people want what he and other area brewmasters are making. "We're in a craft beer explosion right now, and people are more receptive," he said.

Tri-Cities Pro-Brewers Guild

In 2015, the Tri-Cities Pro-Brewers Guild was born out of a need to have a community of local brewers to make decisions that would impact their local businesses. Many of the issues that face breweries and cider

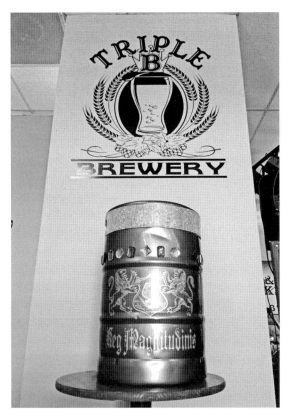

Left: The Keg of Greatness, the official mascot of Tri-Cities Craft Beer Week, makes its debut at Triple B Brewery's grand opening. *Courtesy of Aaron Carson.*

Below: Tri-Cities Pro-Brewers Guild. A meeting of the minds at Bristol Brewery. *Courtesy of Aaron Carson.*

makers are local, and it made sense to expand that and build on the great foundation everyone had built. Aaron Carson, with guidance from the local breweries, CVB's, Andrew Felty and Andrew Fisher, started the Tri-Cities Pro-Brewers Guild.

"There is a sharing and camaraderie in the brewing community that isn't replicated in other industries, with the East Tennessee brewers really extending a hand to help out their fellow brewers. It's an amazing spirit that helps promote East Tennessee and the Tri-Cities brewing brand and community."

Michael Foster and other breweries and cideries—including Depot Street Brewing, Johnson City Brewing, Sleepy Owl Brewery, Holston River Brewing, Studio Brew, Yee-Haw Brewing Company, Bristol Brewery, JRH Brewing Company and Gypsy Circus Cider Company—make up the Tri-Cities Pro Brewers Guild.

Abingdon's Wolf Hills Brewing Company, Damascus Brewery and Old Glade Brewery Brewery are all associate members.

Together, they possess a better buying power to the larger supplies makers, as well as have the ability to put forth a single idea or issue they want to get behind. Separately, they feel they wouldn't be as effective, and because of that, they have held quarterly meetings where they can talk shop and figure out what matters to them in terms of a collective greater good. "Brew locally and act locally" is their motto.

Knoxville Area Brewer's Association

The Knoxville Area Brewer's Association (KABA) held its first general meeting on January 25, 2016. KABA is an association that includes brewers and beer-related businesses in the Greater Knoxville area. KABA is composed of a board, and inaugural president Adam Palmer hosted the first meeting at his brewery.

The inaugural board included Adam Palmer, president; Adam Ingle, vice-president; Zack Roscop, secretary; Matt McMillan, treasurer; and Jeremy Walker, member-at-large.

The focus of KABA is to promote the interests of craft beer businesses in Knoxville and the region. From Visit Knoxville partnerships to building relationships, KABA shows that a rising tide lifts all ships.

The golden age of craft beer is upon us, and East Tennessee leads the way. If you want to continue to see more of these independent and

community-based businesses thrive, make sure to support them and show them that local matters.

Cheers!

As Jack Handy from *Saturday Night Live* said:

> *Sometimes when I reflect back on all the beer I drink I feel ashamed. Then I look into the glass and think about the workers in the brewery and all of their hopes and dreams. If I didn't drink this beer, they might be out of work and their dreams would be shattered. Then I say to myself, "It is better that I drink this beer and let their dreams come true than be selfish and worry about my liver."*

No truer words were ever spoken.

BIBLIOGRAPHY

Brown, Fred. Article 5. *Knoxville News-Sentinel*.

Castle, Kevin. "Beer Is an Art—A Very Tasty Art." *Bristol Herald Courier*, June 28, 2014. http://www.heraldcourier.com/news/local/beer-is-an-art-a-very-tasty-art/article_24875f22-fe6c-11e3-95b1-001a4bcf6878.html.

Duncan, Heather S. "Hellbender Hops Farm Reintroduces Locally-Grown Hops to East Tennessee After a Century." *Knoxville Mercury*, June 6, 2015. http://www.knoxmercury.com/2015/06/17/hellbender-hops-farm-reintroduces-locally-grown-hops-to-east-tennessee-after-a-century/.

John (No last name). "613 McGhee Street—Knoxville Brewing Company." Knoxville Lost and Found. September 4, 2012. http://knoxvillelostandfound.blogspot.hk/2012/09/613-mcghee-street-knoxville-brewing.html.

Johnson City Press. "Organizers Look Forward, Kick Back During 15th Blue Plum." November 25, 2014. http://www.johnsoncitypress.com/gallery/Organizers-look-forward-kick-back-during-15th-Blue-Plum?ci=stream&lp=7&p=2.76923076923077.

King, Roger. *Knoxville Journal*, October 11, 1980.

Knoxville News-Sentinel, September 21, 1955.

Knoxville Register. Article 13. March 6, 1839.

Ridenour, Donny. "Prohibition and the Legalization of Liquor in Knoxville." March 20, 1992.

INDEX

A

Alliance Brewing Company 94, 95
Atlantic Ale House 64, 65, 66

B

Bearden Beer Market 53, 60, 61, 66, 94, 95, 96
Blackberry Farm 99, 100, 101, 102
Blackhorse Pub & Brewery 102, 103, 104
Blue Hop BrewHaHa 25, 134, 155
Bluetick Brewery 105, 106, 107
Brewers Summit 133
Brewhibition 133, 155
Brewly Noted Beer Trail 140, 141, 142, 144, 156
Bristol Brewery 69, 70, 71, 72, 146
Bubba's Barrels 45, 112

C

Casual Pint, the 21, 63, 64
Cherokee Distributing 22, 23, 24
cider 72, 73, 74, 75, 82, 134, 136, 144, 146, 156
Cold Fusion Brewing 107, 108, 109
Crafty Bastard Brewery 110, 111, 112

D

Depot Street Brewing 21, 32, 38, 39, 40, 47, 87, 144, 146
distributors 22, 24, 25, 26, 45, 103, 104, 108, 121
Downer, Ron 37, 100
dry majority 12, 27

E

Eagle Distributing Company 22, 24, 53
East Tennessee Brewing Company 13

Index

F

Fanatic Brewing Company 22, 37, 113, 114, 115, 116

G

Gypsy Circus Cider Company 72, 73, 74, 136, 146, 156

H

Hellbender Hops Farm 51
Hexagon Brewing Company 130, 131
Holston Distributing Company 22, 24, 25
Holston River Brewing Company 75, 76, 77, 146
hops 13, 49, 50, 51, 109

J

Johnson City Brewing Company 80, 81, 82, 146
JRH Brewing Company 78, 80, 136, 146

K

King Family Farm 49
Knox Beer Snobs 52, 53, 54, 61, 143
Knox Brew Fest 132
Knox Brew Tours 57, 58
Knoxville Area Brewer's Association (KABA) 146
Knoxville Brewers Association (KBA) 13
Knoxville Brewers' Jam 56, 129, 132
Knoxville Brewing Company (KBC) 13
Knoxville Craft Beer Week 143

L

Landis, Michael 52, 135
Last Days of Autumn Brewing Company 116, 117
Libation Station 61, 62
liquor tax 27
Lundberg, Jon 137, 139, 156

M

moonshine 18, 19, 20

N

New Knoxville Brewing Company (NKBC) 13, 31, 37, 121

P

Pretentious Beer Glass Company 58, 59
prohibition 12, 13, 18, 27, 28, 29, 40, 133

R

Racks by the Tracks 134, 136

S

Saw Works Brewing Company 31, 37, 119, 120, 121, 122, 123
Scruffy City Brewery 98, 99, 117, 119

INDEX

Sleepy Owl Brewery 83, 84, 85, 86, 146
Smoky Mountain Brewery 35, 37, 41, 43, 56
Sophisticated Otter Restaurant and Brewing Company 31, 32, 33, 87
South College 43, 47, 120
State of Franklin Homebrewers 56, 57, 87
Studio Brew 52, 86, 87, 146
Suttree's High Gravity Tavern 66, 68

T

temperance 11, 12, 17
Tennessee Championship of Beers 135, 139, 156
Tennessee Craft Beer Month 137, 144, 156
Tennessee Oktoberfest 33, 134, 135, 136, 155
Tennessee Valley Homebrewers 54, 132
Thirsty Orange Brew Extravaganza 52, 84, 134, 135, 139, 144, 155
Tri-Cities Craft Beer Week 25, 143, 144, 156
Tri-Cities Pro-Brewers Guild 144–146, 156
Triple B Brewery 33, 34, 135

W

Wolf Hills Brewing Company 50, 85, 91, 92, 93, 146
Woodruff Brewing Company 35, 37

Y

Yee-Haw Brewing Company 33, 53, 89, 90, 91, 146

ABOUT THE AUTHORS

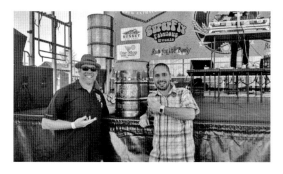

Aaron Carson The craft beer experience for Aaron has been an evolution through all the trials and tribulations that taste buds can offer. He used to think that visiting the Guinness Factory in Ireland or having a Tusker beer in Tanzania was the ultimate beer experience. Over the last decade, he has opened his eyes to his own backyard and realized his fellow Tennesseans are key players in the evolution of craft beer. Although every couple of years there is still a pilgrimage to Belgium to visit another Trappist brewery, the satisfaction is built around helping facilitate the craft growth in East Tennessee. It's always back to where you came from.

Born and raised in East Tennessee, Aaron moved to Asheville, where a broader appreciation of craft beer took hold. From there came the idea of a premier craft beer event for the Tri-Cities, and he approached Kingsport native Robert Brents to create Tennessee's Oktoberfest (formerly Kingsport Oktoberfest). From that event came the Brewer's Summit and Brewhibition in Knoxville to Tri-Cities with the Thirsty Orange Brew Extravaganza and Blue Hop BrewHaHa. Aaron has also created festivals in other parts of North Carolina and Colorado with his company Superfly Fabulous

About the Authors

Events. Through the experience, he found fulfillment in seeing a broader appreciation for the art of craft brewing and the men and women who put their livelihoods and sanity on the line to see a dream become a reality.

As the events began to grow, inside Tennessee as well as in other states, there became a real need to add more layers to this prolific and venerable art. Soon Aaron reached out to Representative Jon Lundberg to declare April Tennessee Craft Beer Month. He didn't stop there. With the help of Andrew Fisher, he created Tri-Cities Craft Beer Week to help propel the recognition of East Tennessee craft beer and some wonderful southwest Virginia breweries.

As the craft experience for the area expanded, so did the opportunities to expand the appreciation of the craft. Aaron, along with BJCP Judge Matt Raby, started the Tennessee Championship of Beers to recognize quality pints in the state and region as Tennessee's first medal event for craft breweries. In addition, Aaron and Andrew Felty reached out to convention and visitors bureaus in the Tri-Cities (Bristol, Kingsport and Johnson City) to create the Brewly Noted Beer Trail to promote craft in the region, along with kick starting the Tri-Cities Pro-Brewers Guild.

Aaron's not stopping there. His next endeavor is Gypsy Circus Cider Company—the first cider company in East Tennessee.

He is a member of the North American Guild of Beer Writers and the United States Association of Cider Makers. In his "spare time," Aaron skis and travels with his family—his incredibly supportive wife, Stephanie (who also loves craft beer), and two amazing girls, Elise and Aubrie.

Tony Casey Having grown up in the Adirondack Mountains of upstate New York, early on in his three decades–long life, Tony found his love for beer.

Like his brothers and sisters, at an early age, he rocketed into the food and drink business. Because his parents were always owning and operating restaurants throughout his formative years, he began working more than forty-hour weeks at a suspiciously early age but loved every minute of it, taking in the vast amount of alcohol and culinary information necessary to run such a business.

Around his twenty-first birthday, or a few years before (who's counting?), Tony took particular interest in his family restaurant's seasonal tap, which would change with the seasons and pour whatever was considered local, fresh and fun for the craft beer–loving customers who came in to eat his family's tasty foods. With Montreal, Québec; Lake Placid, New York; and

About the Authors

Burlington, Vermont, all less than an hour away, delicious Northeast beers were readily available.

After graduating from the State University of New York at Plattsburgh with a journalism degree, Tony eventually moved to Johnson City, Tennessee, with his darling soon-to-be-wife, Ashley, who was pursuing nurse and nurse practitioner degrees through East Tennessee State University.

Tony has worked at area newspapers and has been a daily reporter and columnist for the *Johnson City Press* for nearly three years, frequently writing about his favorite things: food, craft beer, adventure and distance running.

When Tony and Ashley aren't drinking local craft beers in East Tennessee and Western North Carolina, you can find their names in the results of distance races near and far.

Visit us at
www.historypress.net

This title is also available as an e-book